Johanna Basford

Magical Jungle

An Inky Expedition & Coloring Book

PENGUIN BOOKS

PENGUIN BOOKS

An imprint of Penguin Random House LLC

375 Hudson Street

New York, New York 10014

penguin.com

ISBN 978-0-14-310900-6

Printed in the United States of America

1 3 5 7 9 10 8 6 4 2

Interior designed by Johanna Basford
and Sabrina Bowers

This book belongs to

..

Hidden inside this book are . . .

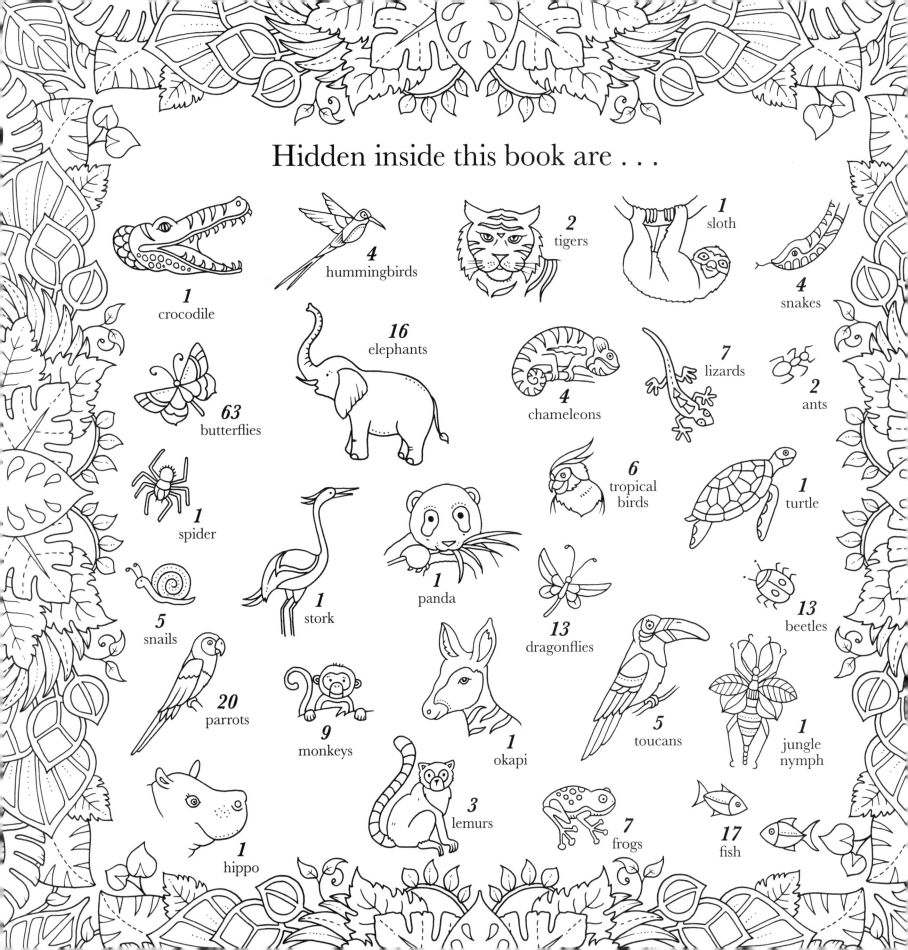

1 crocodile

4 hummingbirds

2 tigers

1 sloth

4 snakes

63 butterflies

16 elephants

4 chameleons

7 lizards

2 ants

1 spider

6 tropical birds

1 turtle

5 snails

1 stork

1 panda

13 dragonflies

13 beetles

20 parrots

9 monkeys

1 okapi

5 toucans

1 jungle nymph

1 hippo

3 lemurs

7 frogs

17 fish

Introduction

Let your imagination run wild in the Magical Jungle as you color and bring to life its exotic flora and fauna. From tropical birds to rare orchids, curious chameleons, and the odd okapi, this lush rainforest is teeming with wildlife and inky inspiration for your colorful creations.

There are lots of creatures, big and small, hiding in the undergrowth.
Can you find them all?

Tips for exploring:

- Use the color palette test page at the back of this book to test your pencils and pens.

- Pencils are the most versatile medium for coloring and will allow you to mix and blend your colors.

- Pens will give you a vibrant pop of color, but don't press too hard, and remember to test them before you dive in!

- Don't worry if you go over the lines.

- Share your creations with friends or post pictures on social media with the hashtag #MagicalJungle. It's fun to show off your masterpieces!

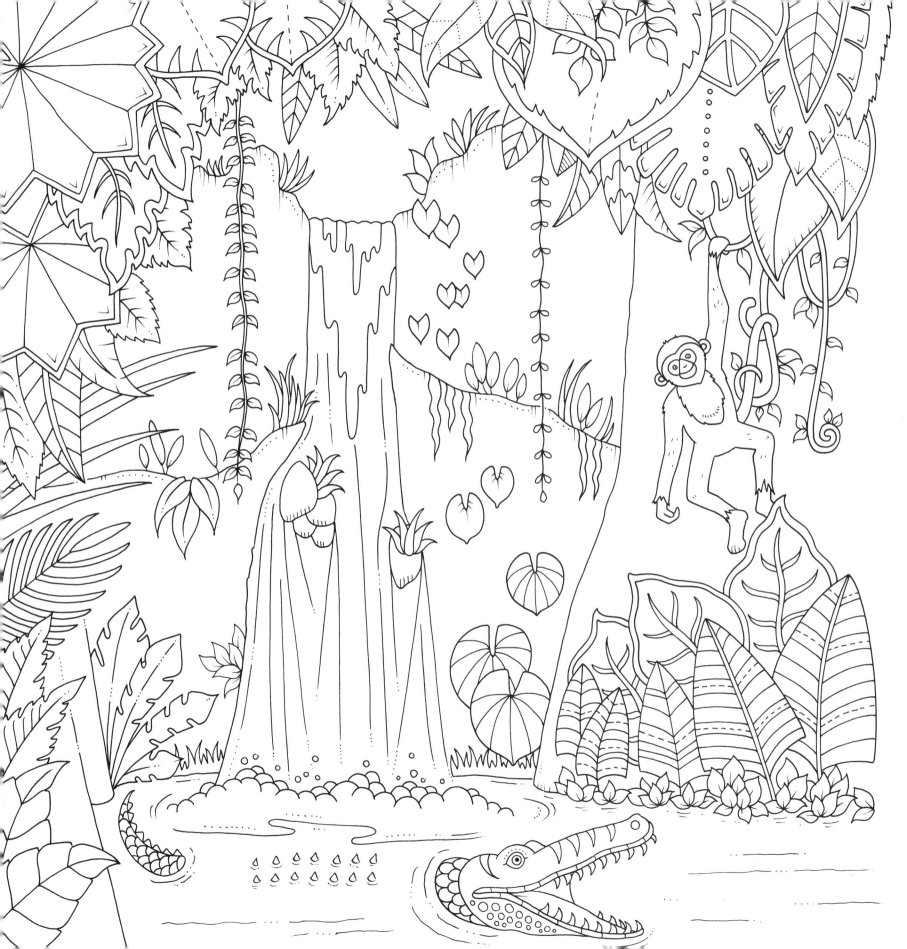

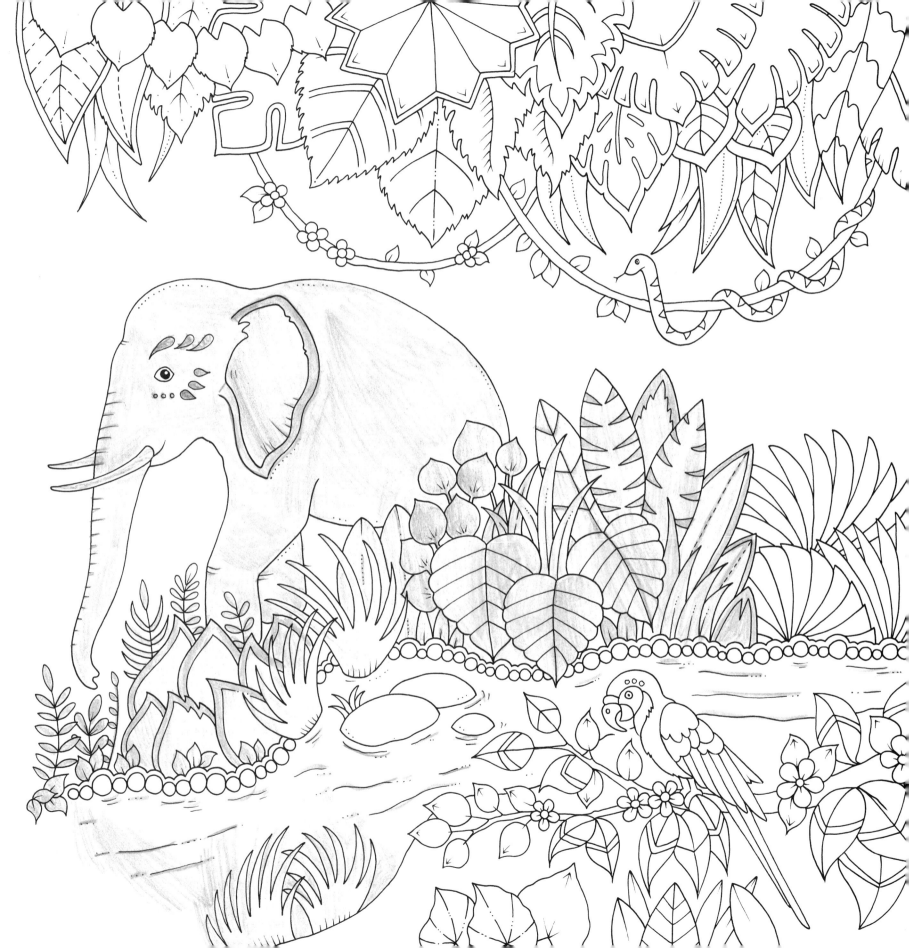

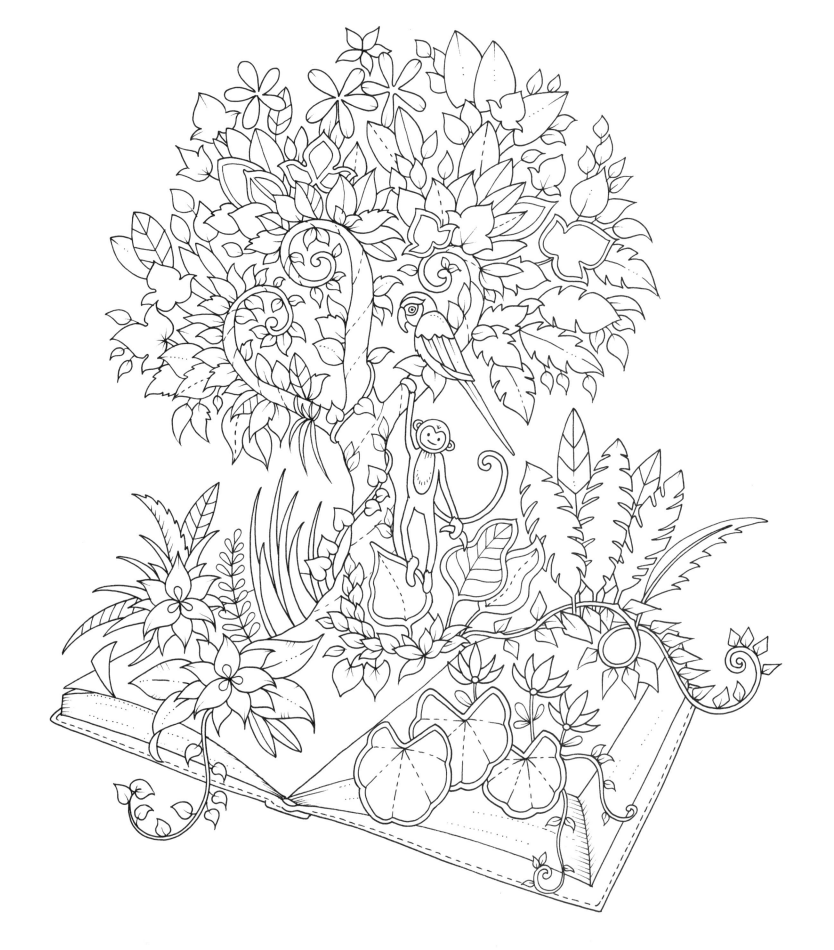

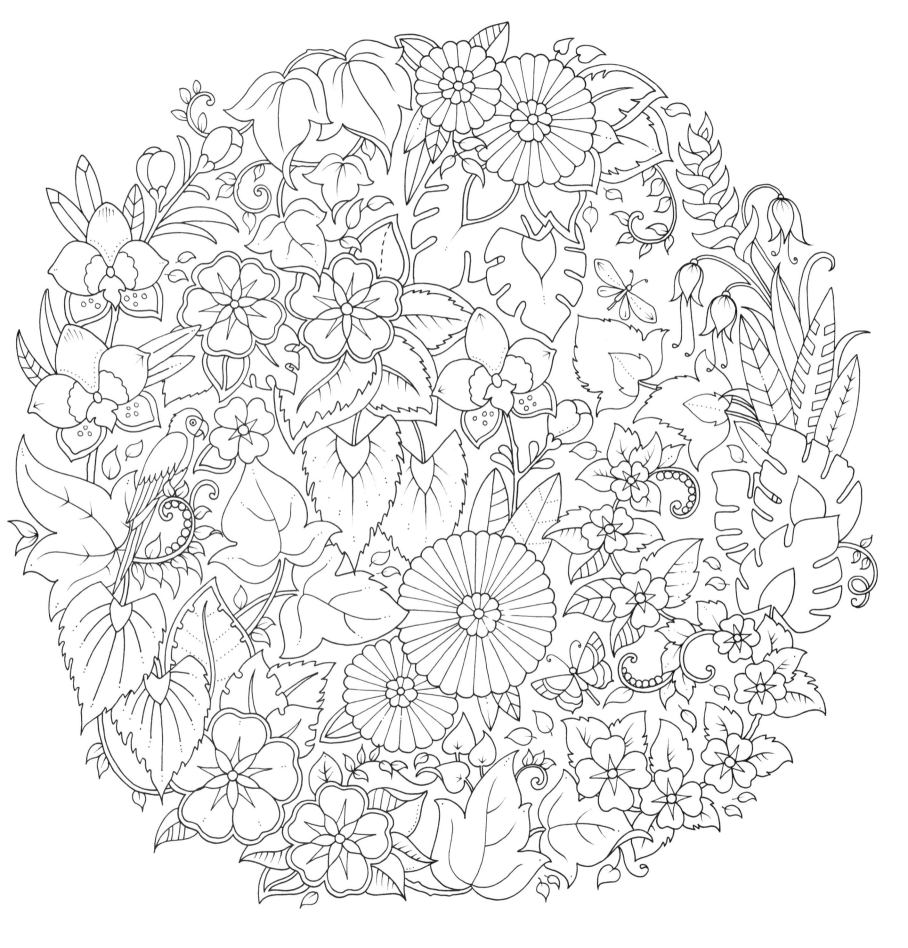

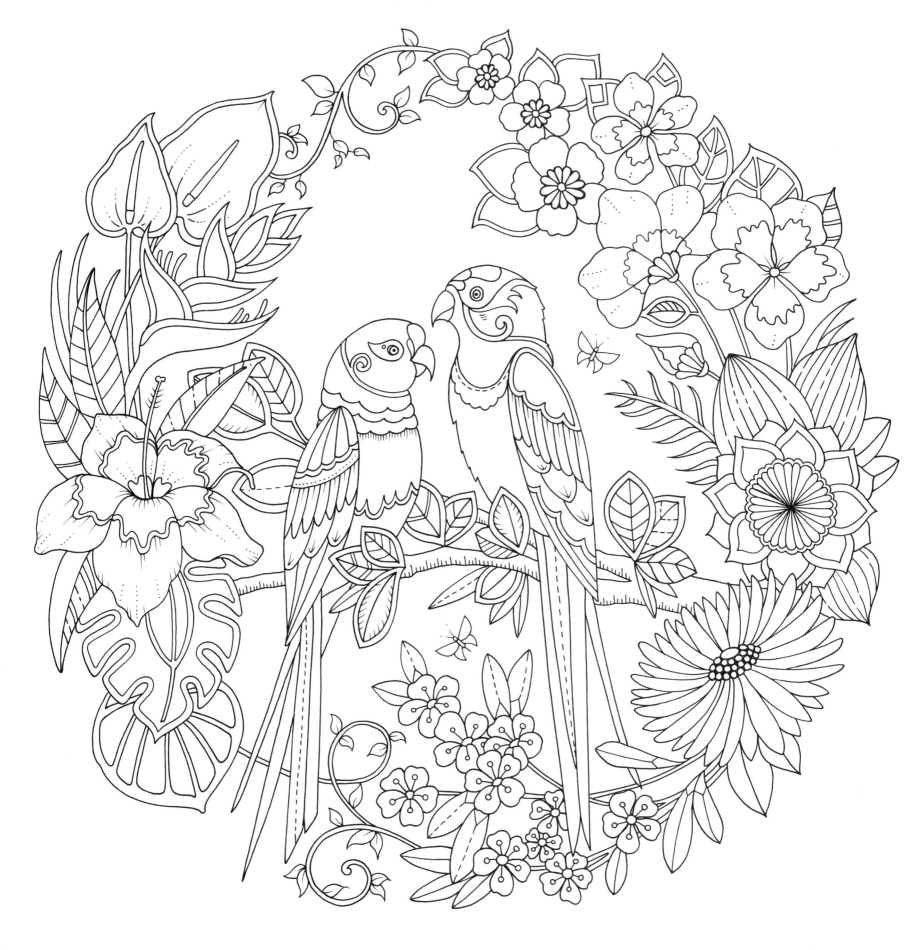

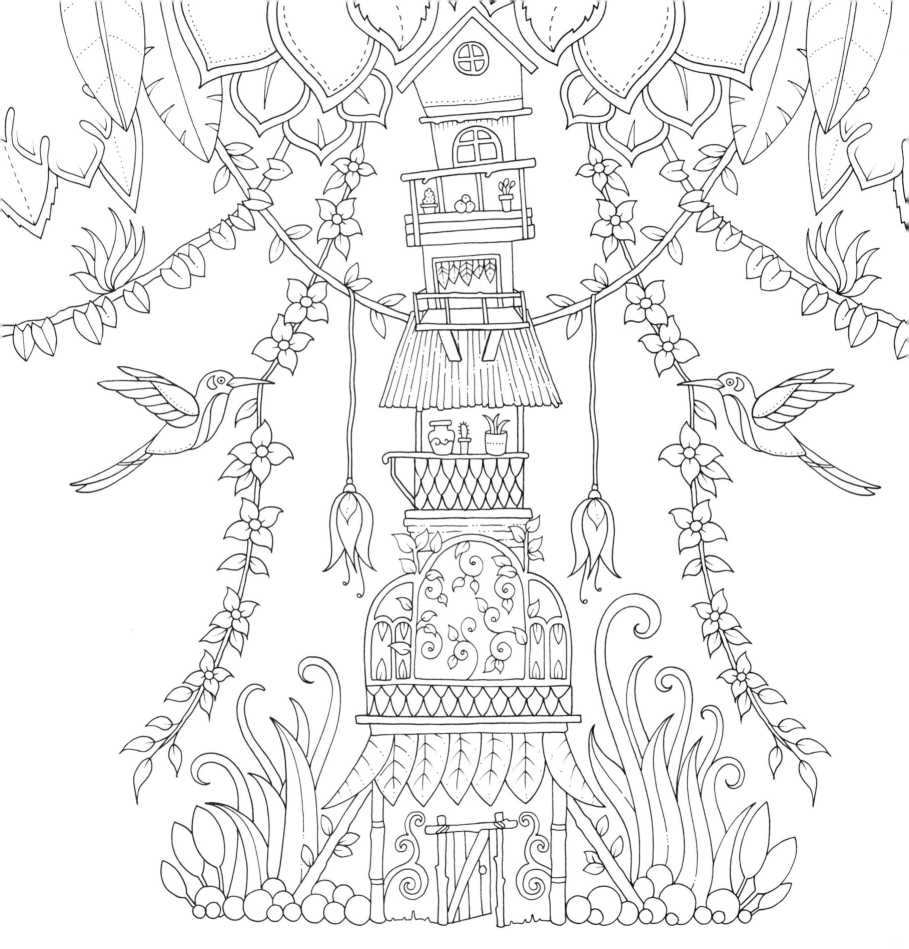

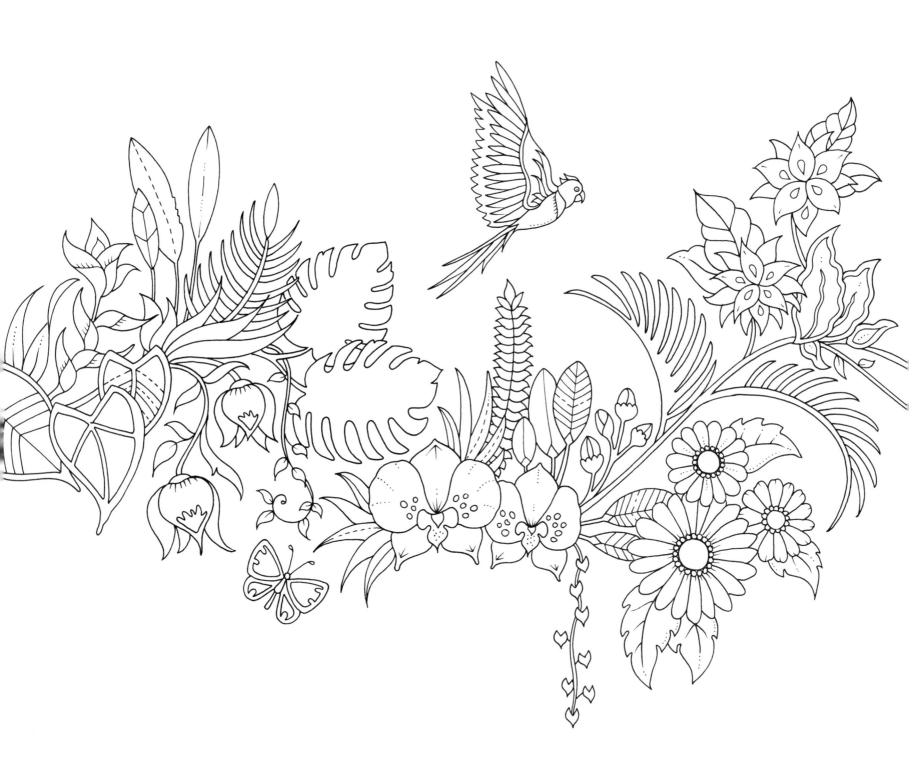

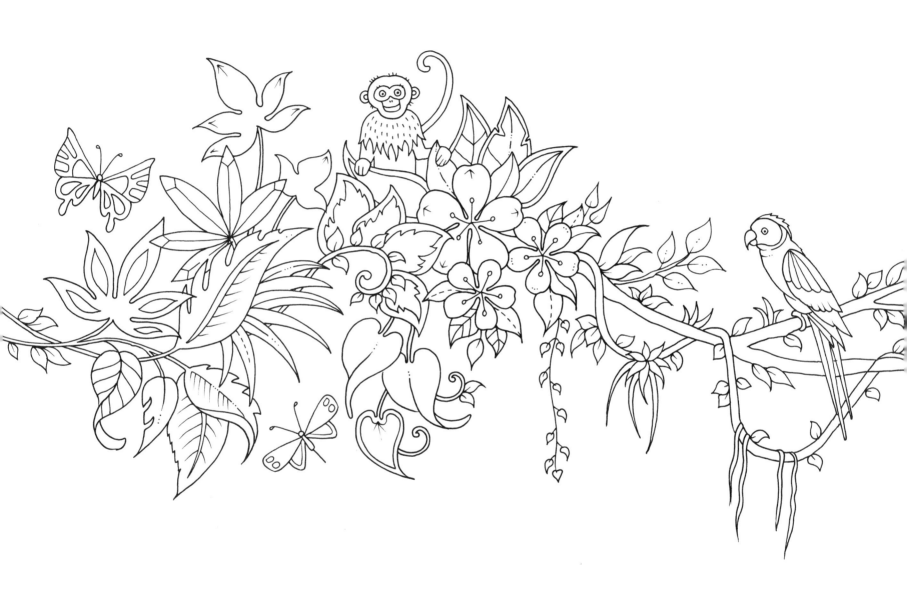

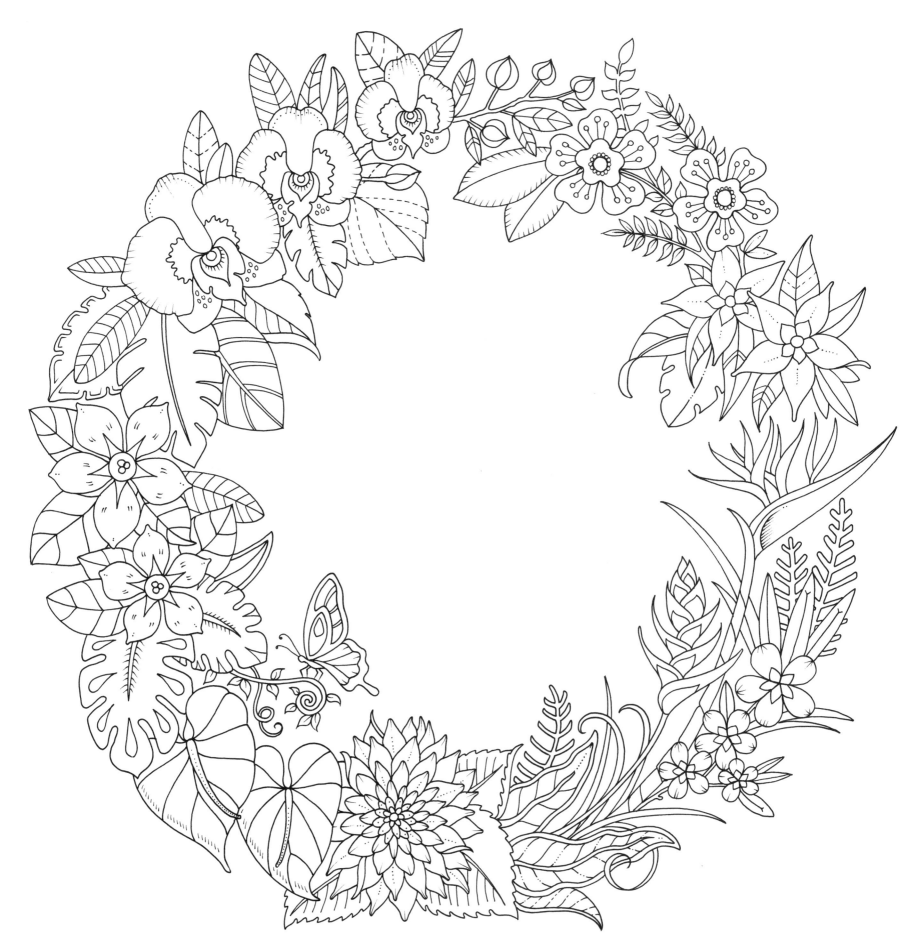

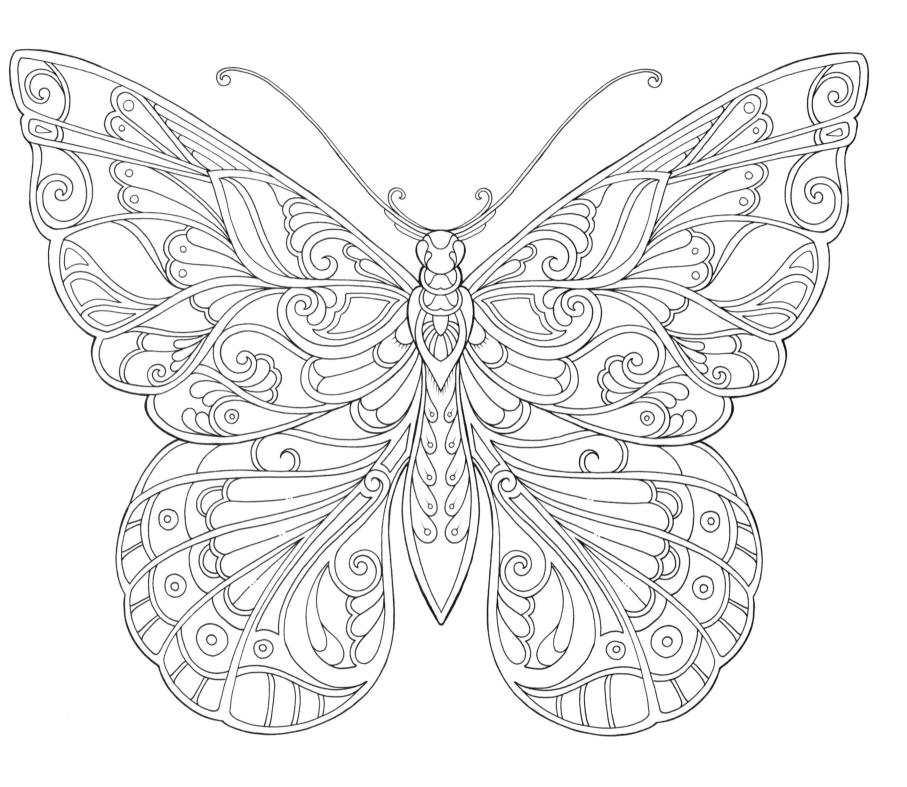

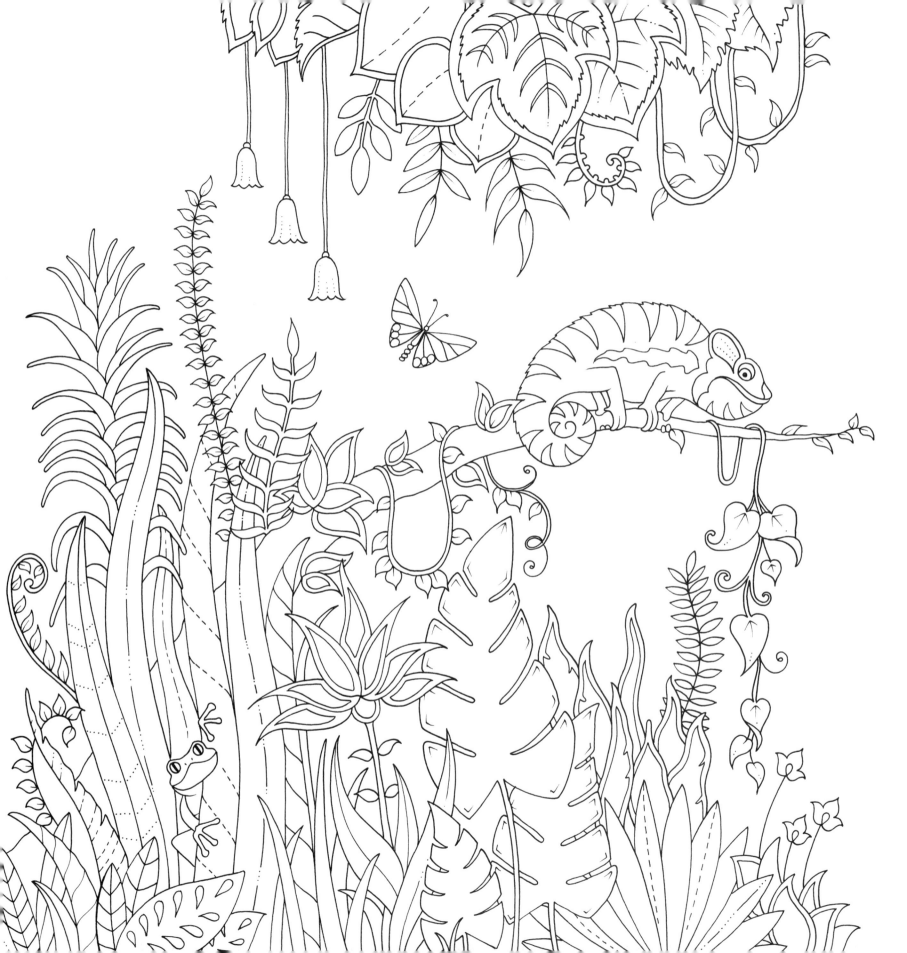

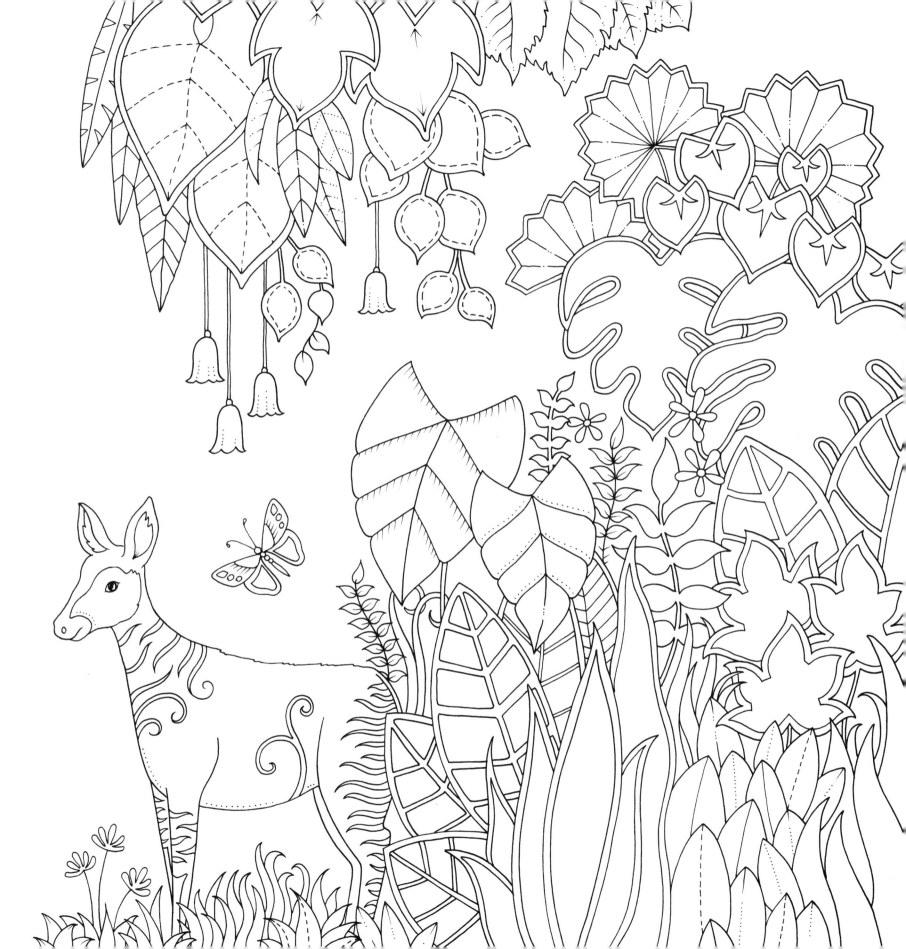

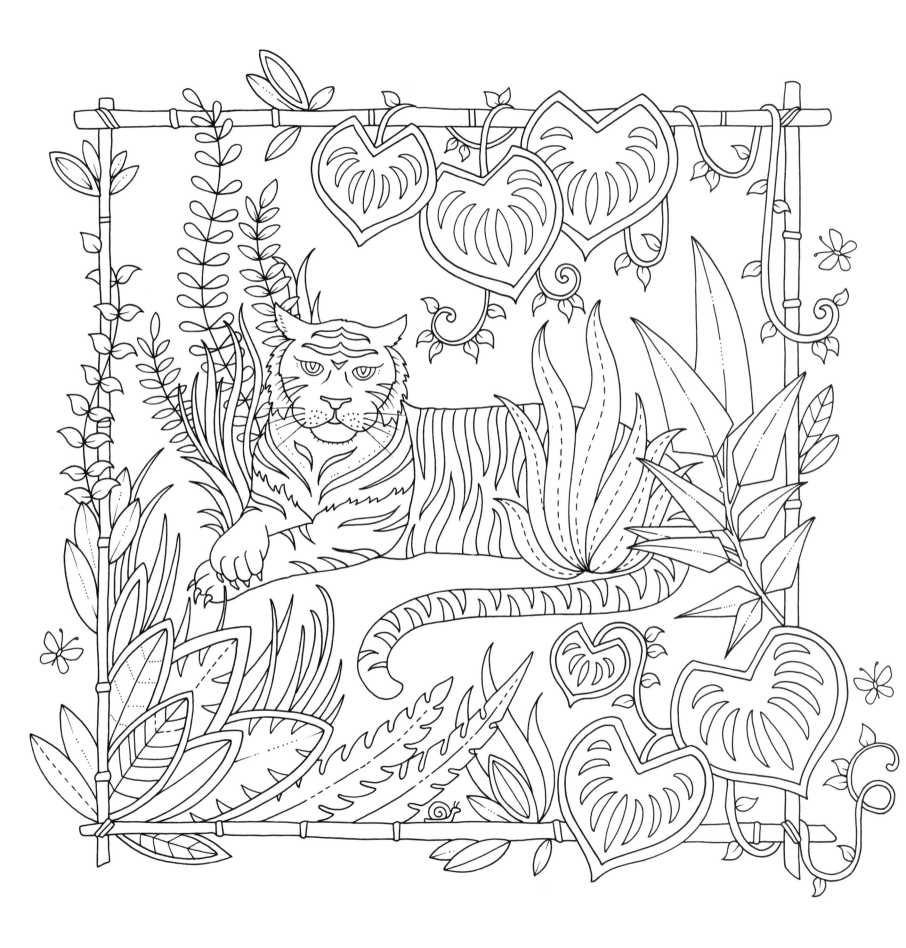

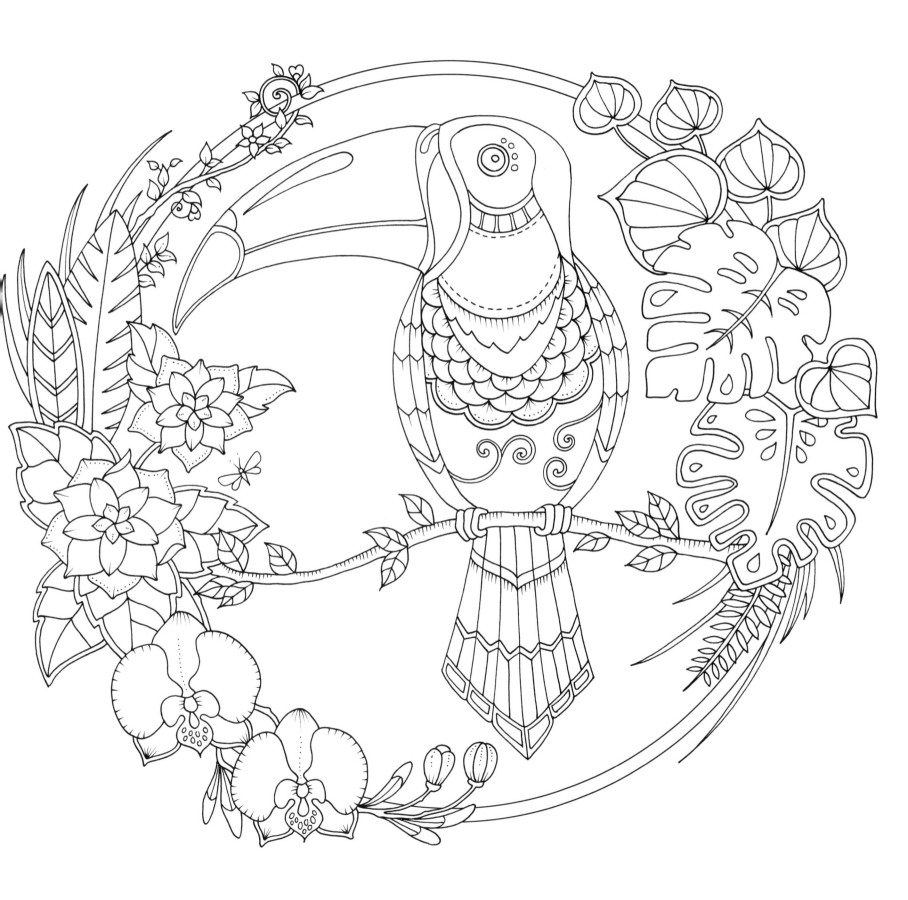

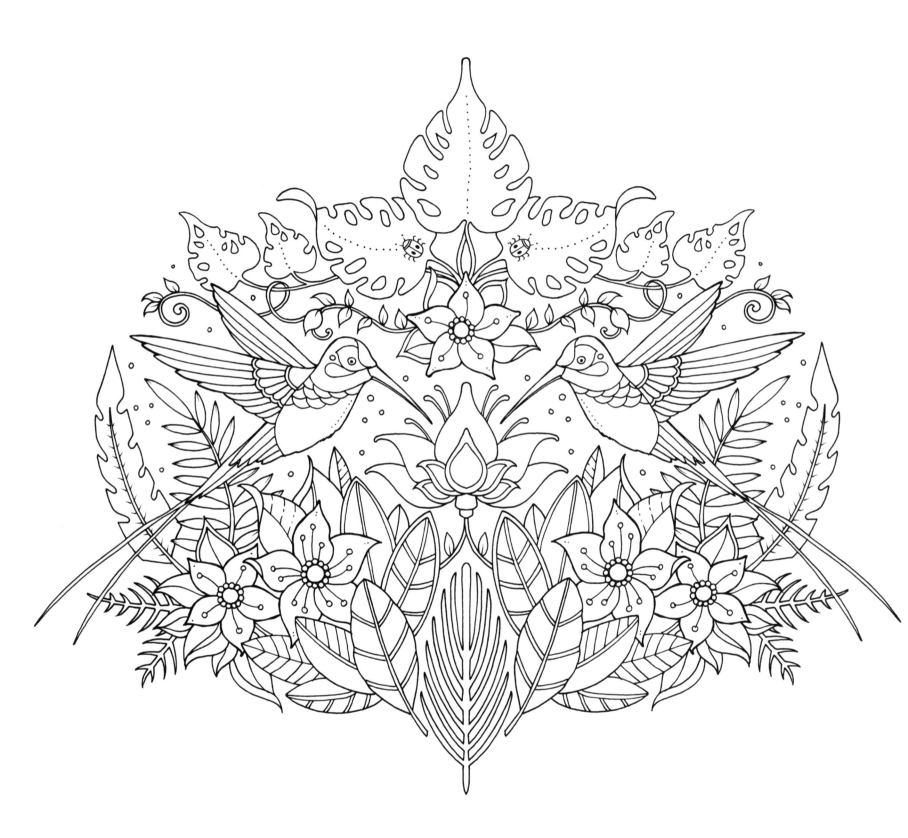

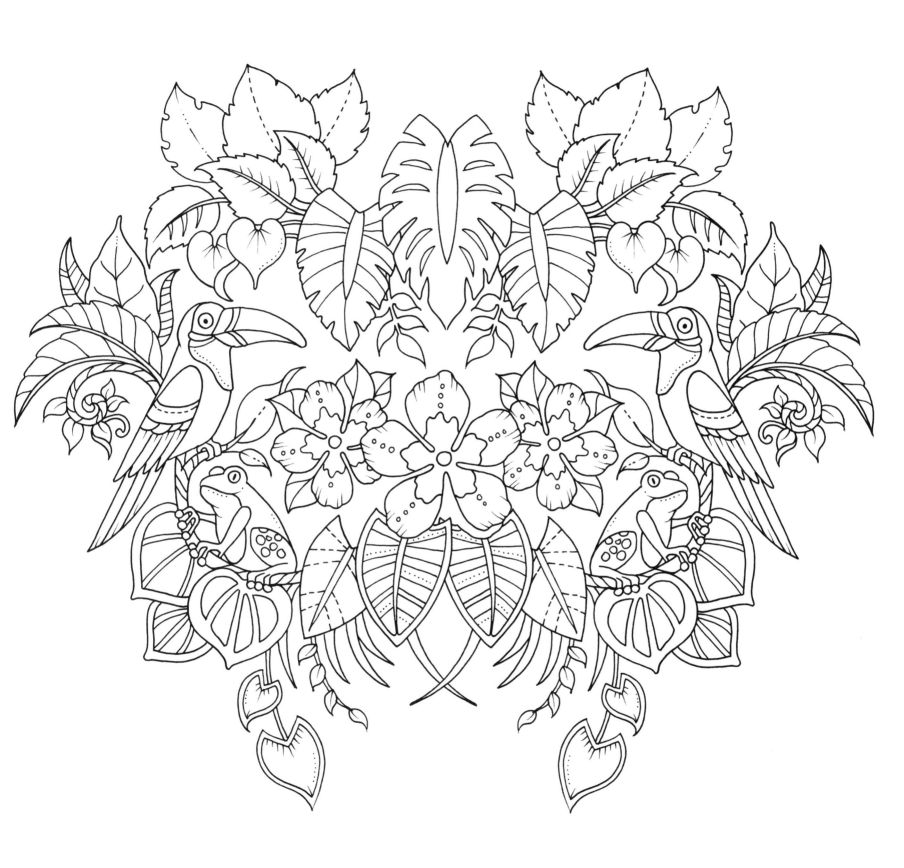

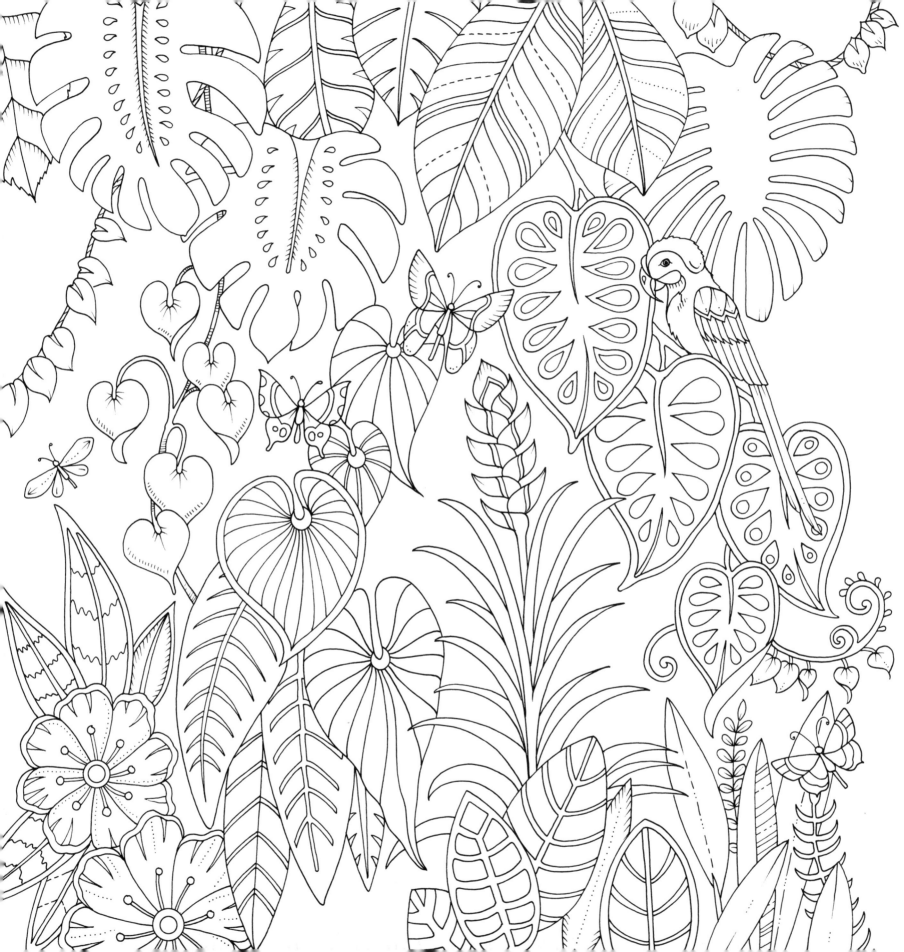

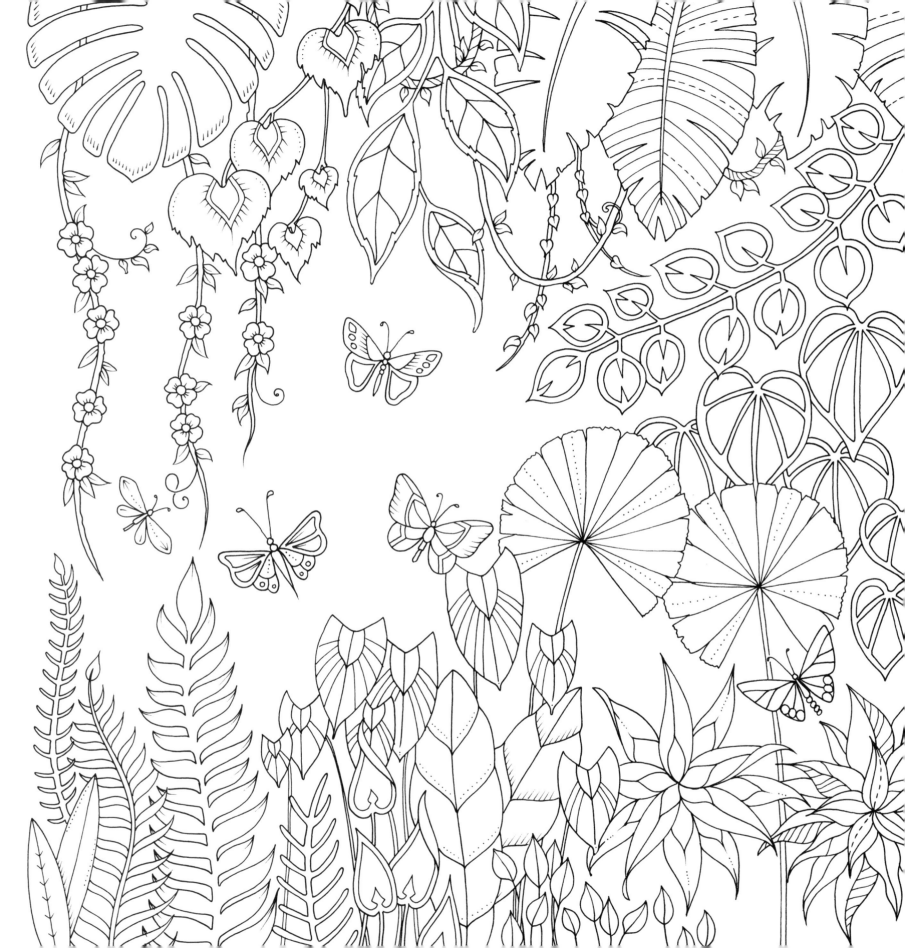

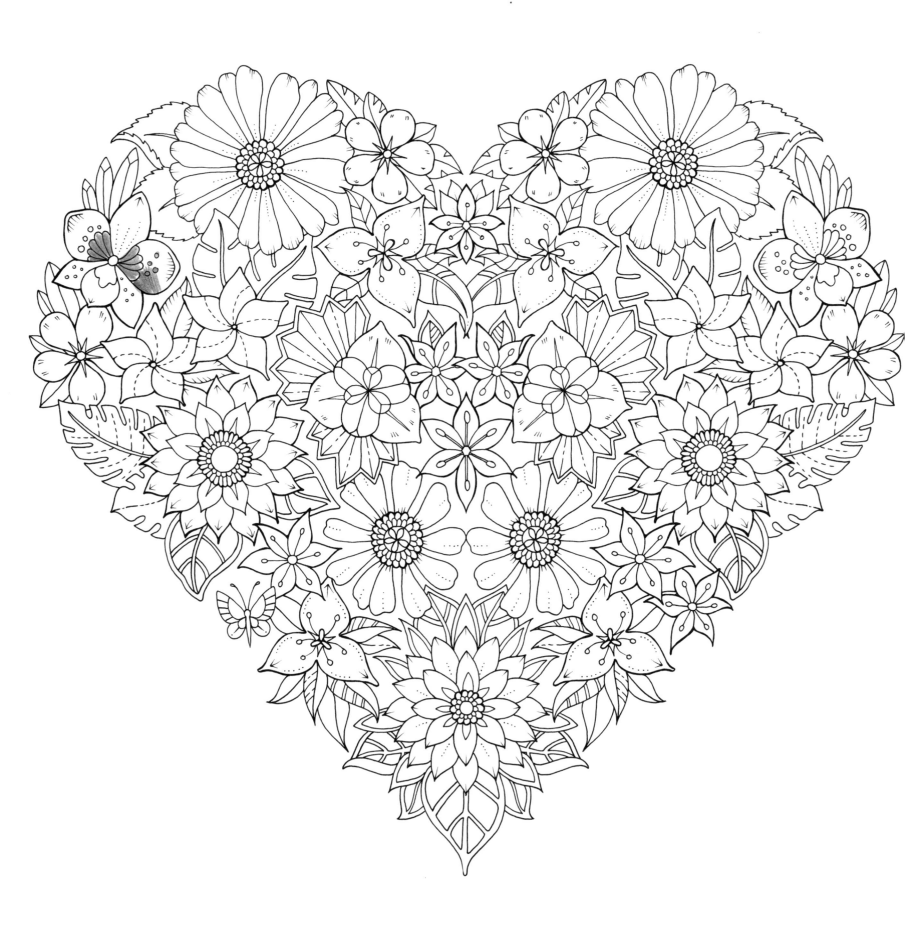

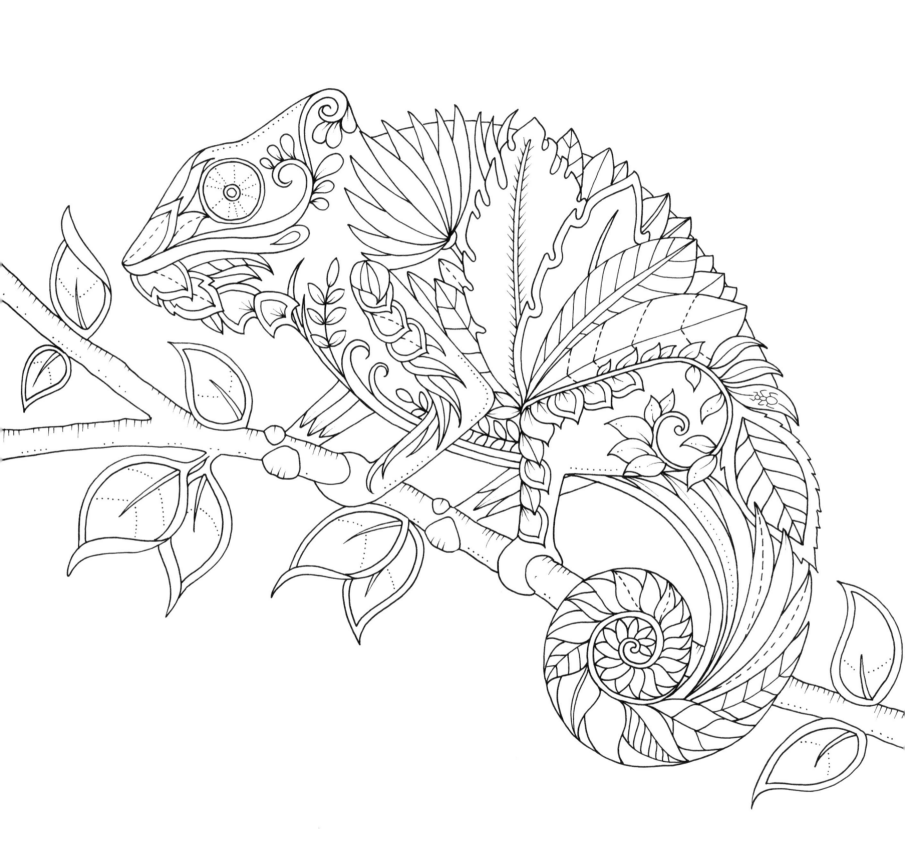

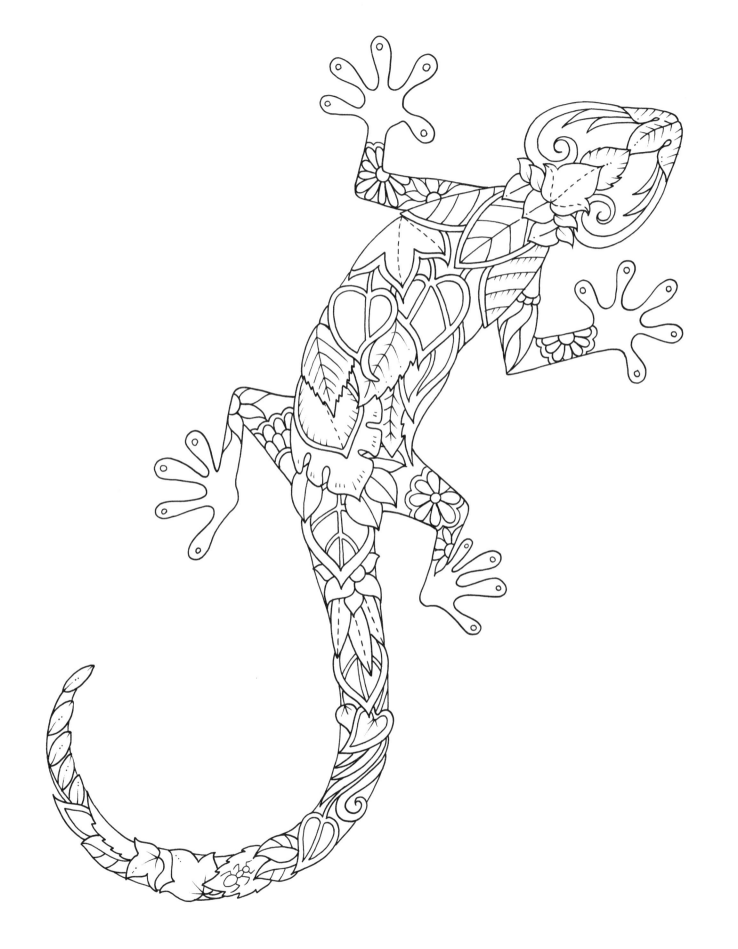

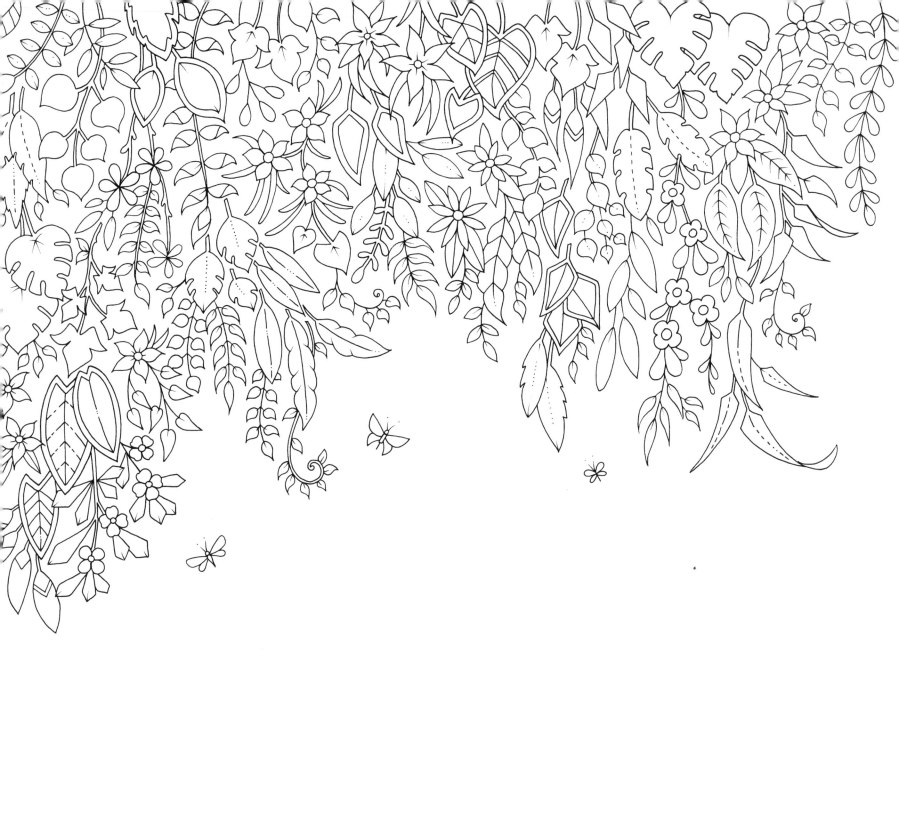

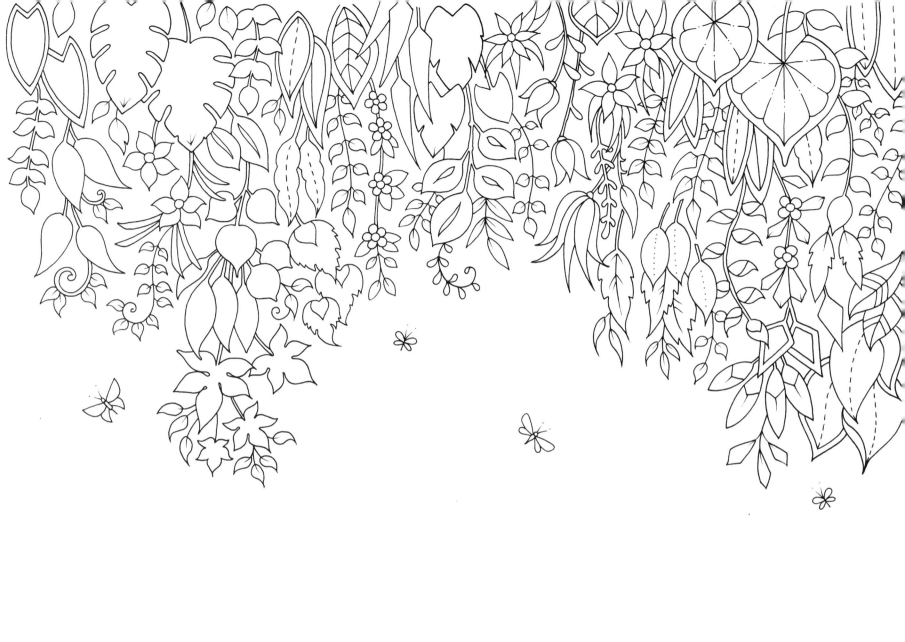

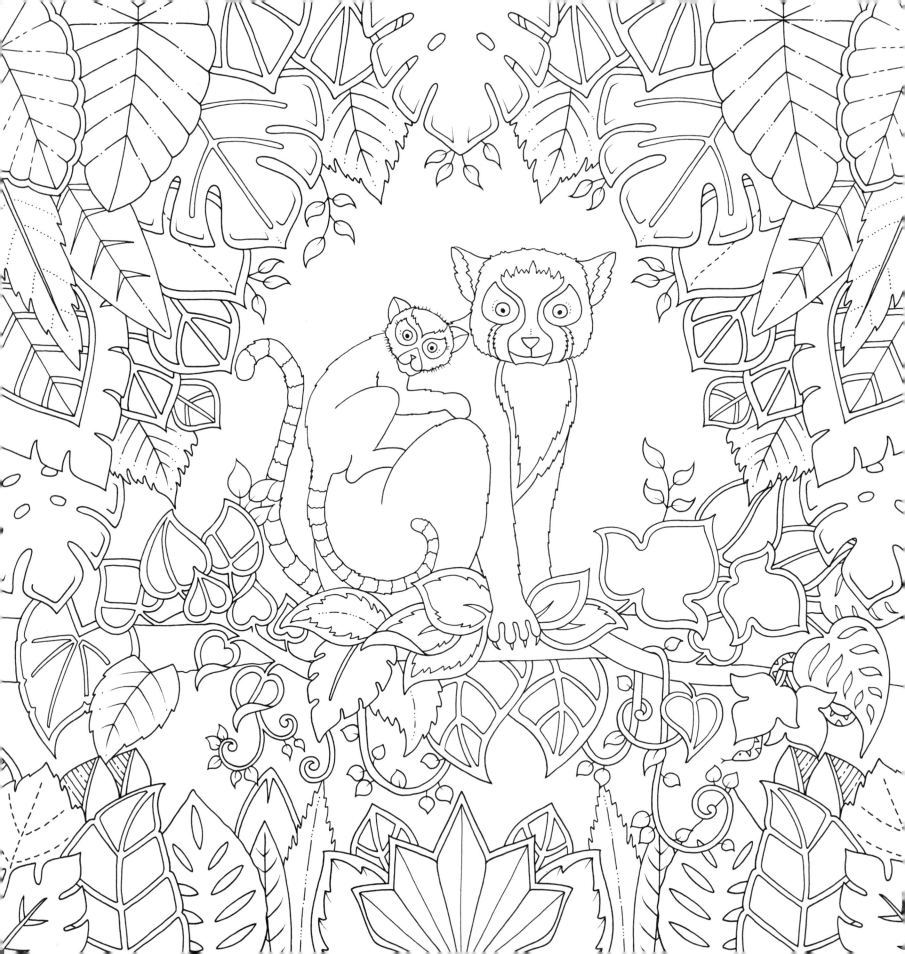

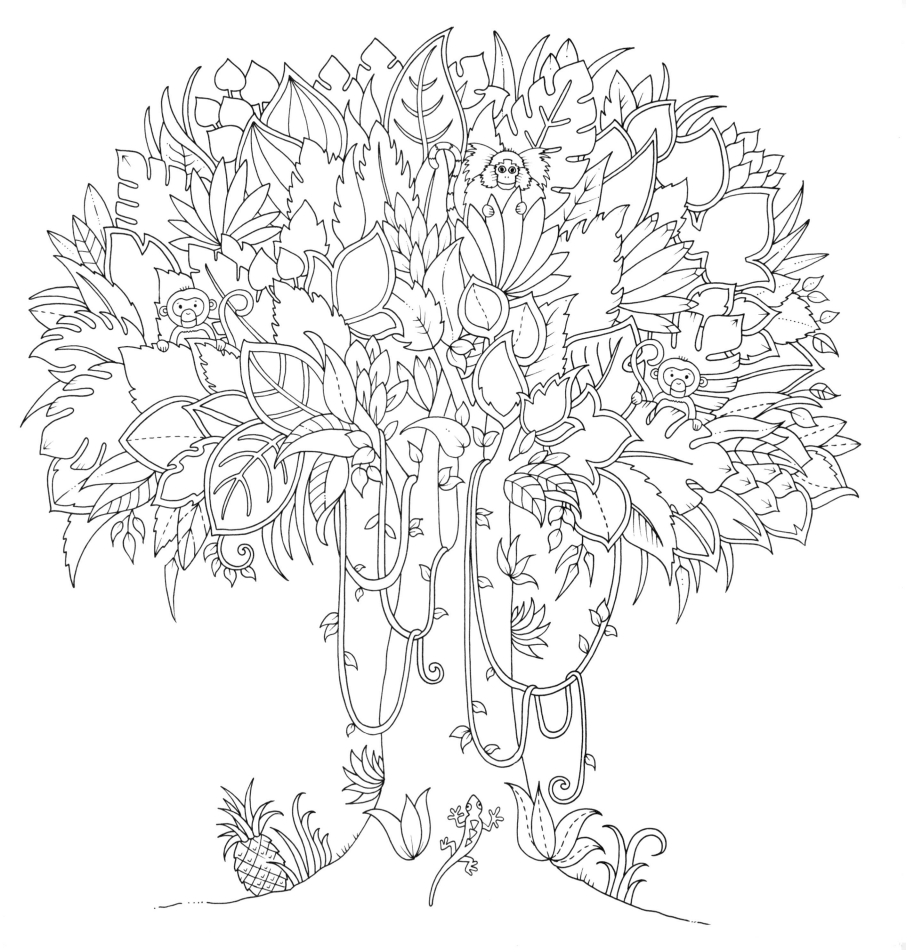

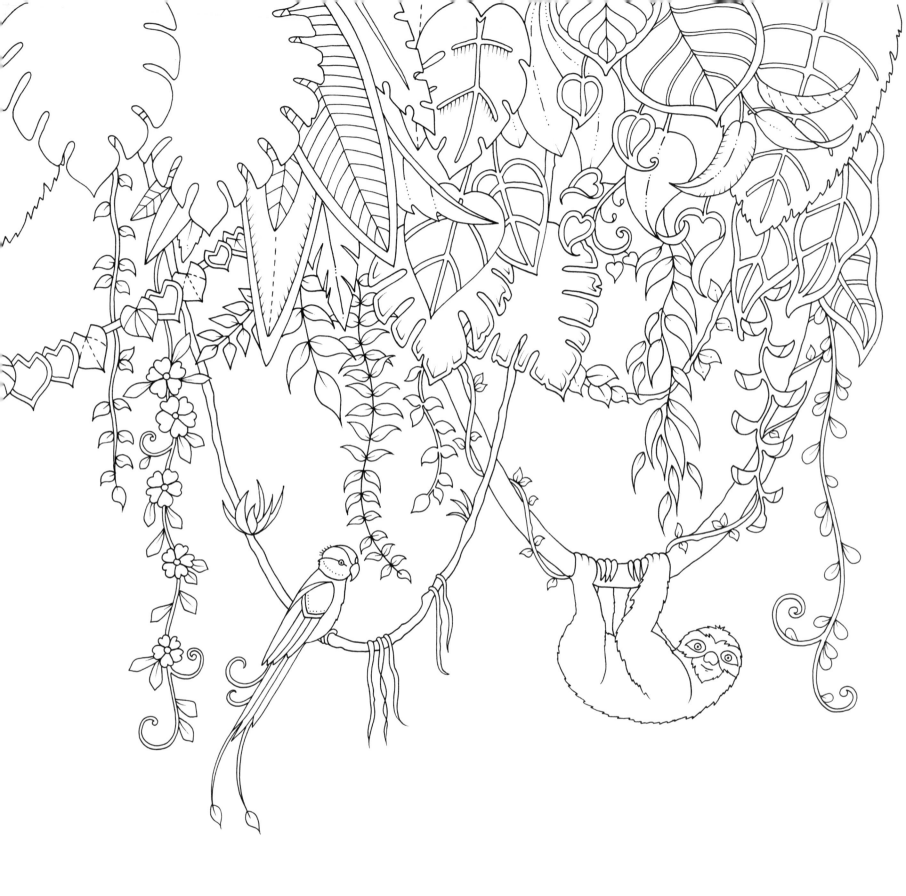

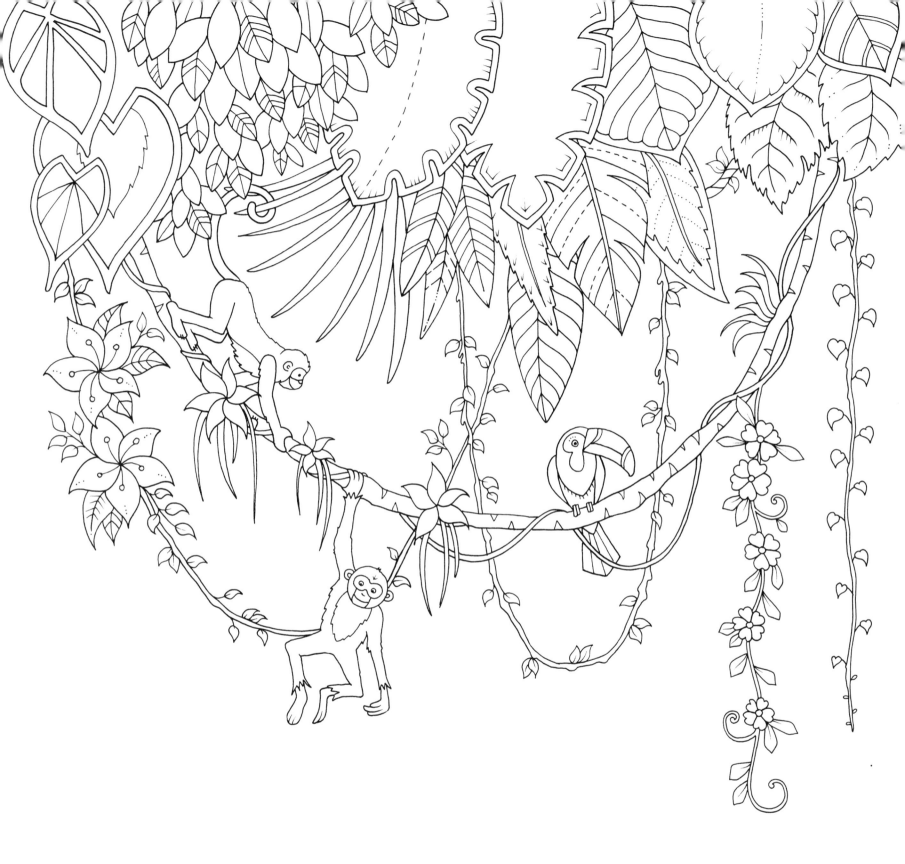

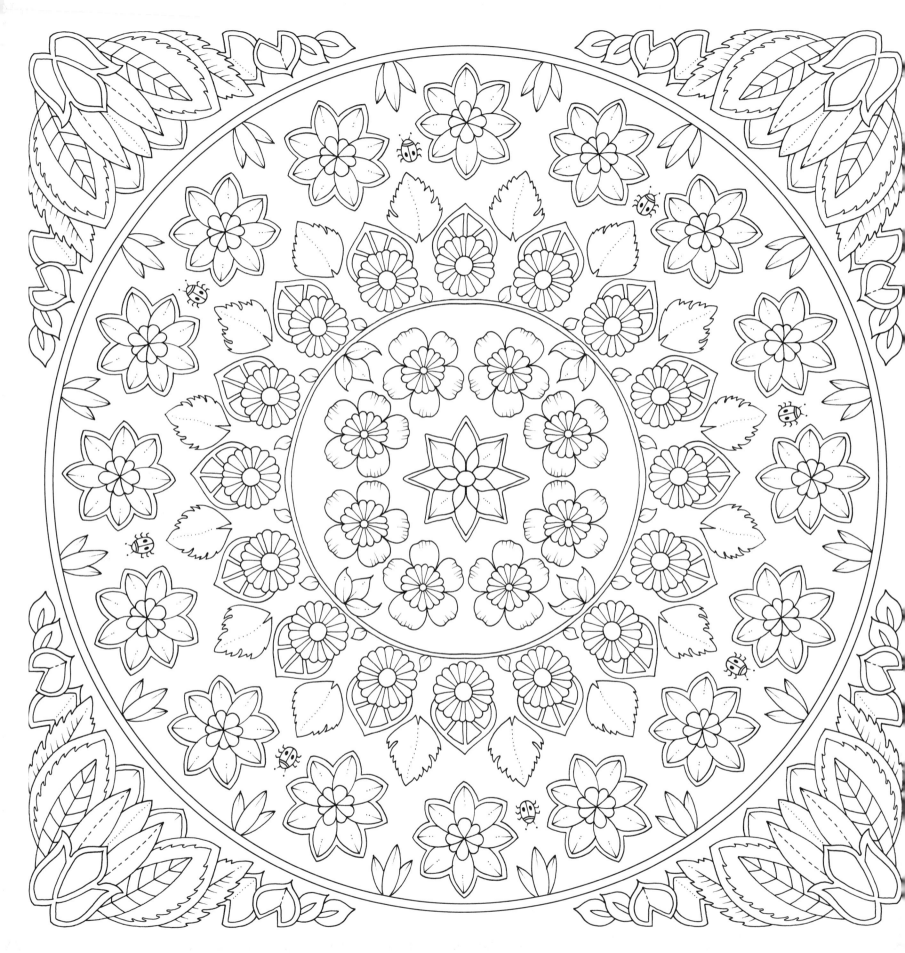

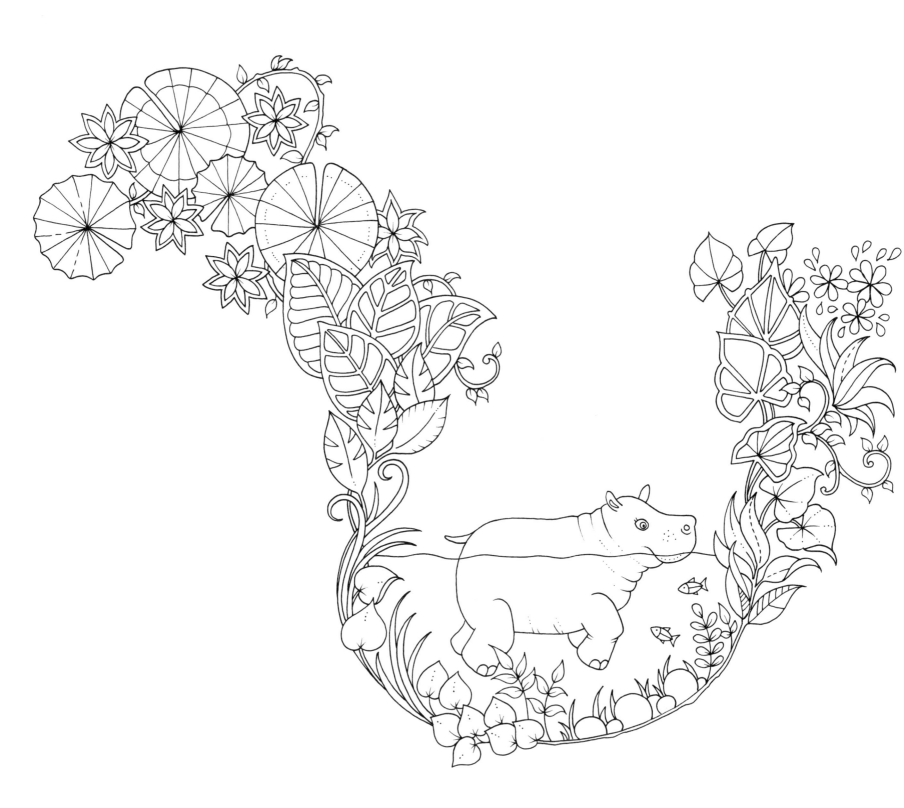

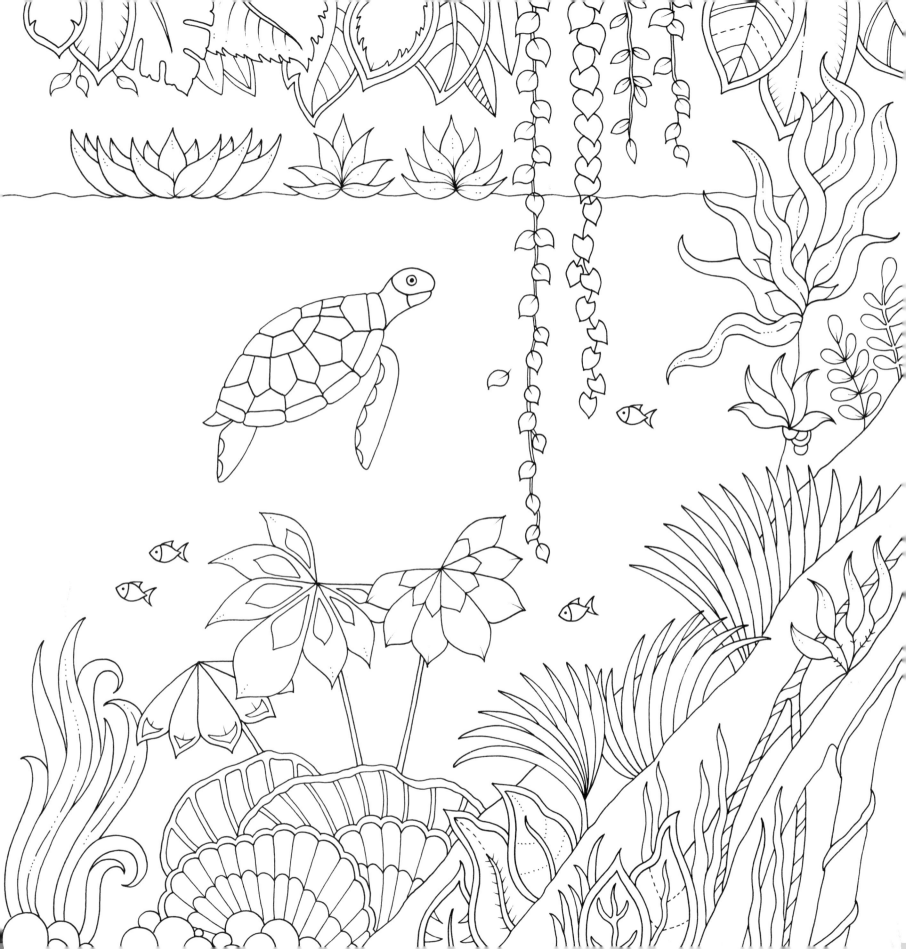

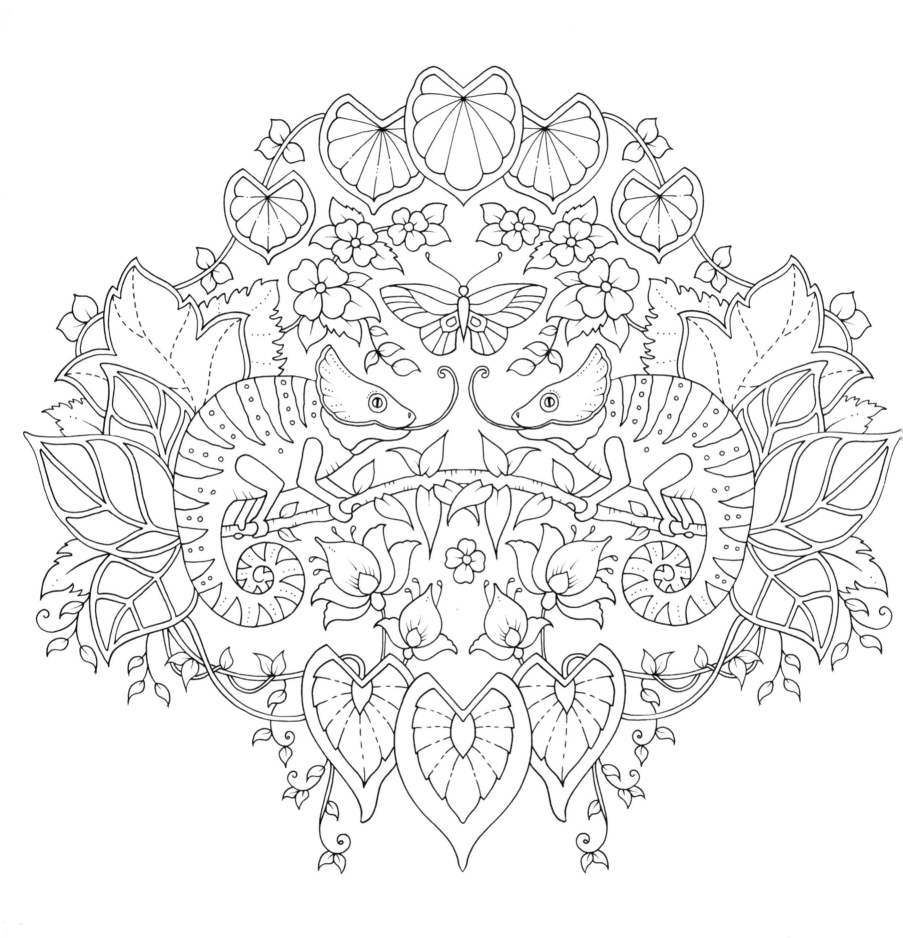

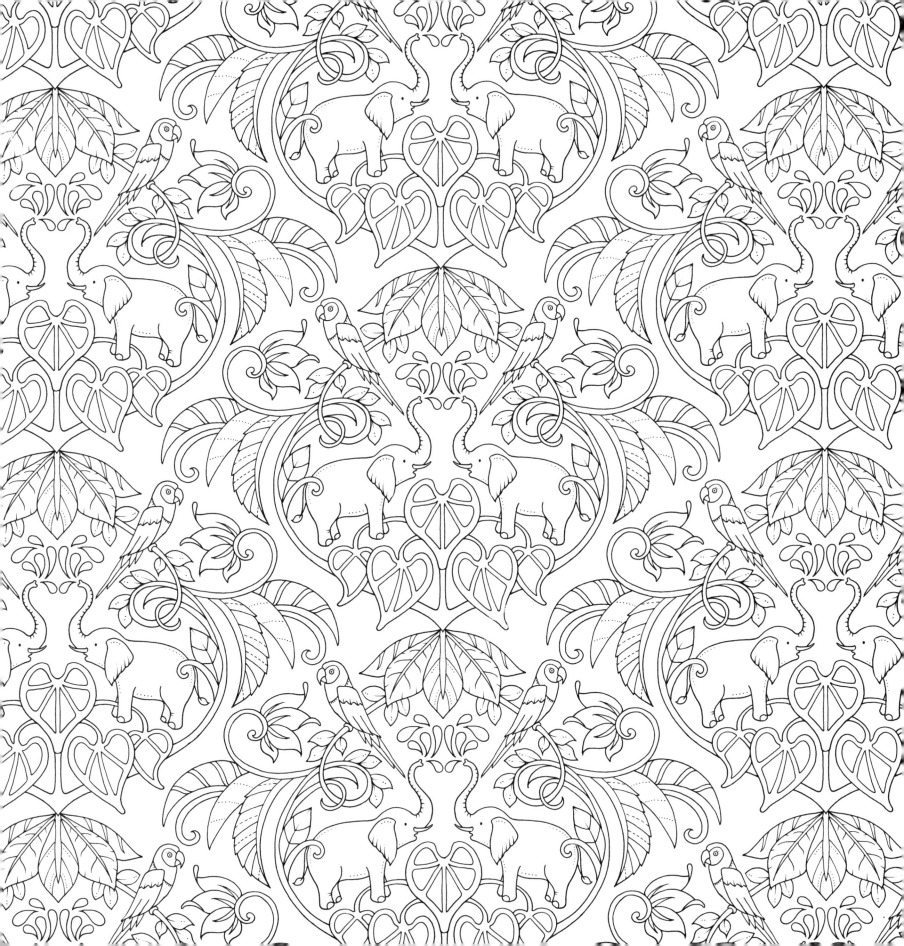

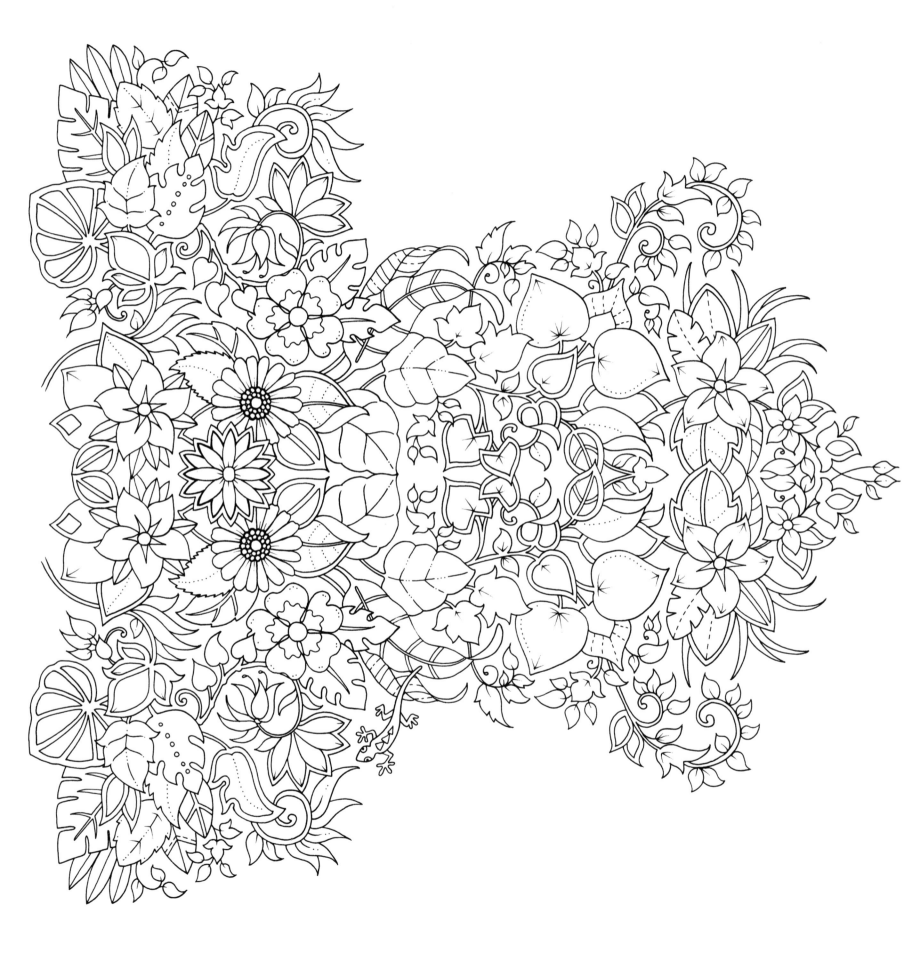

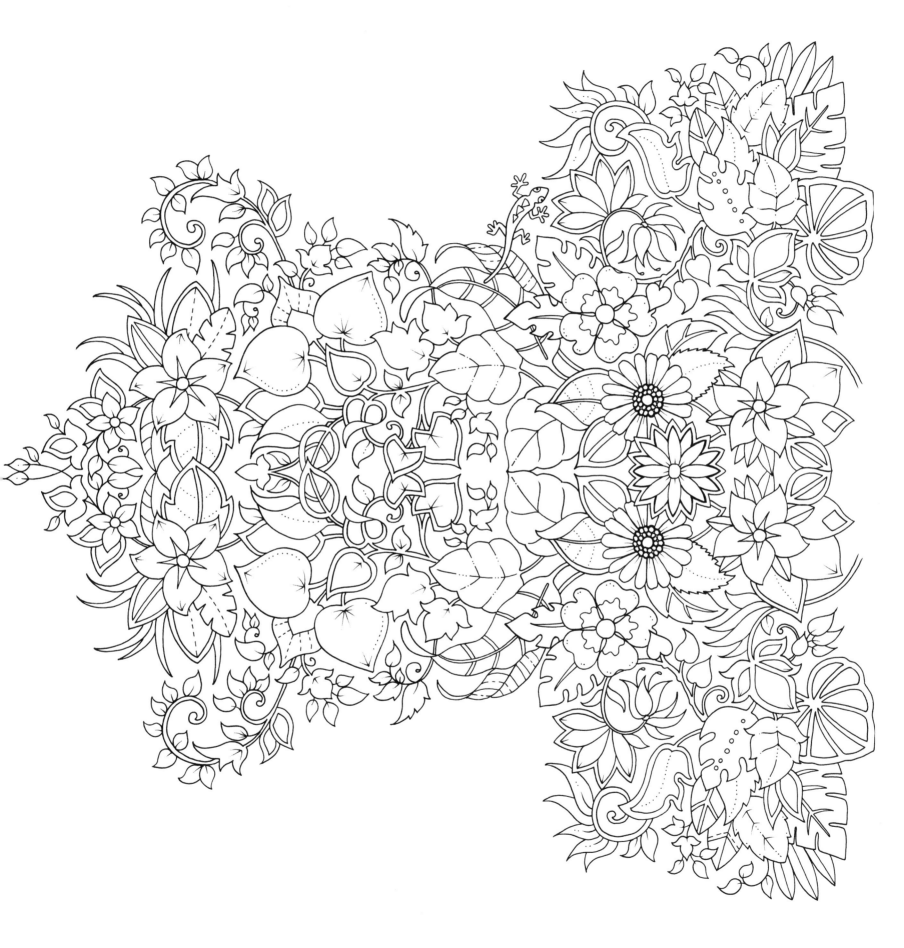

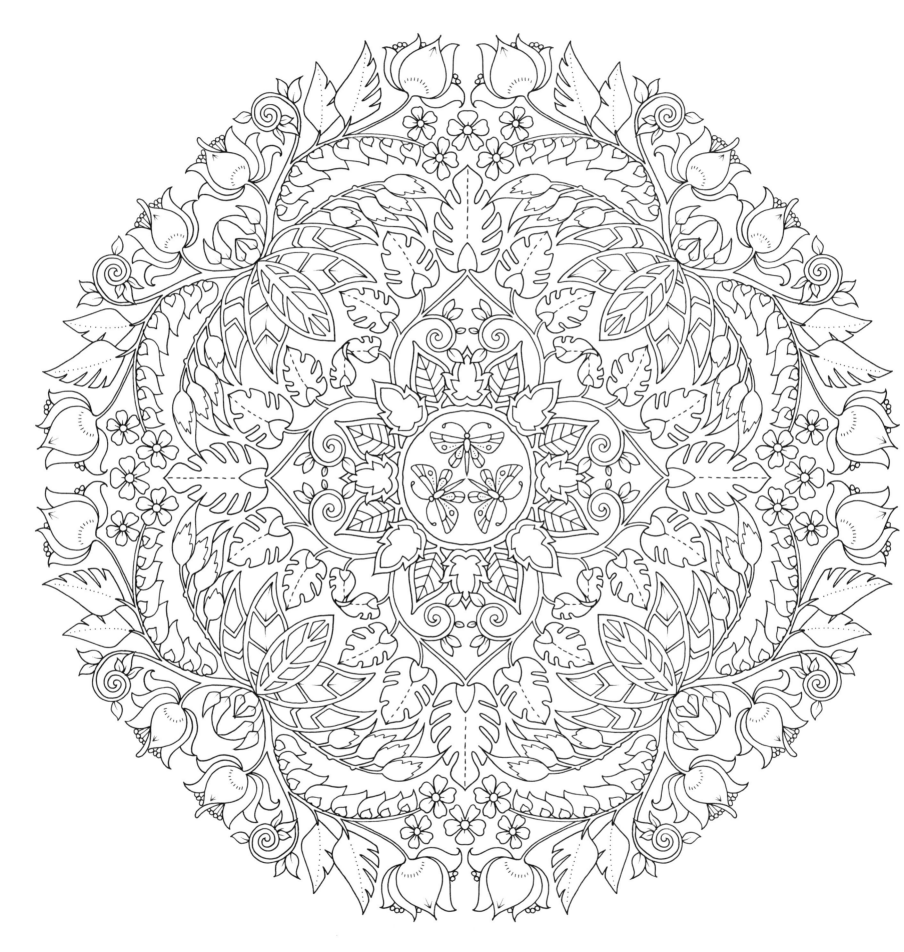

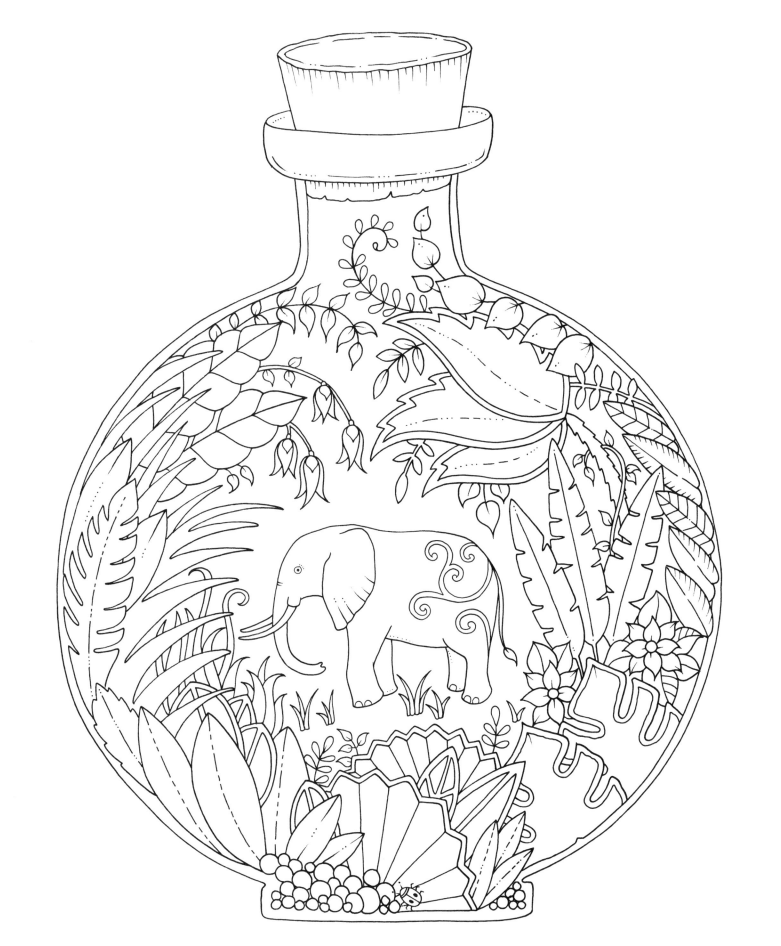

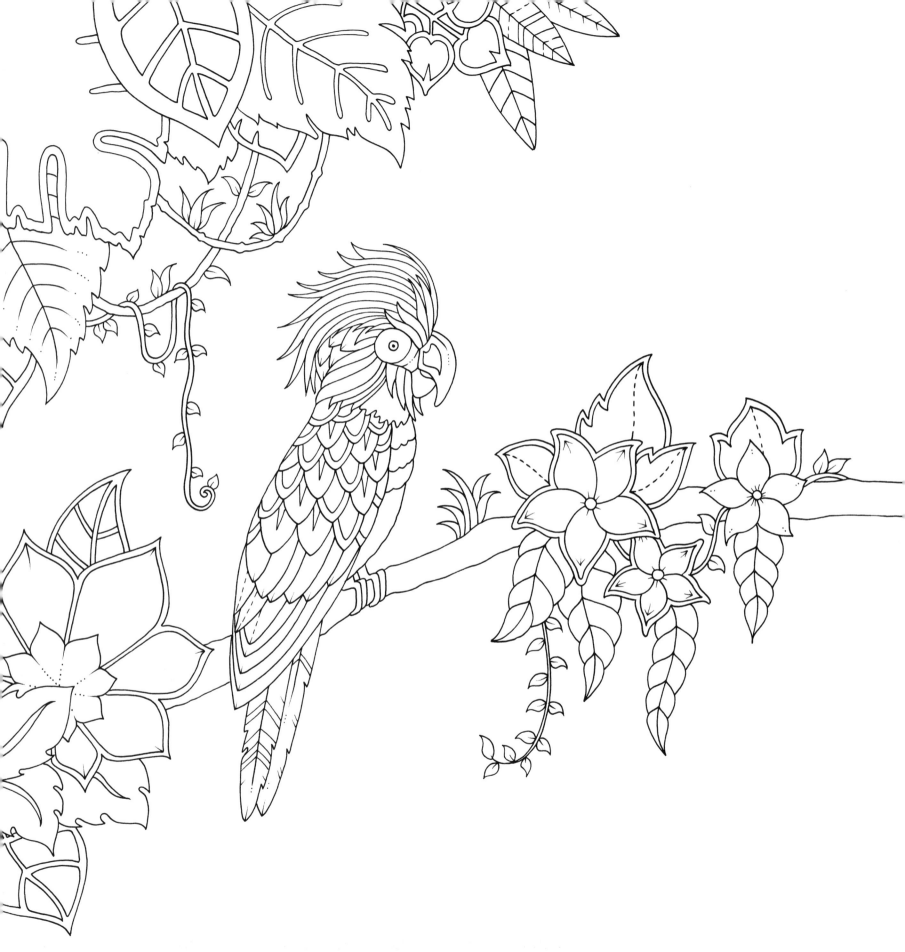

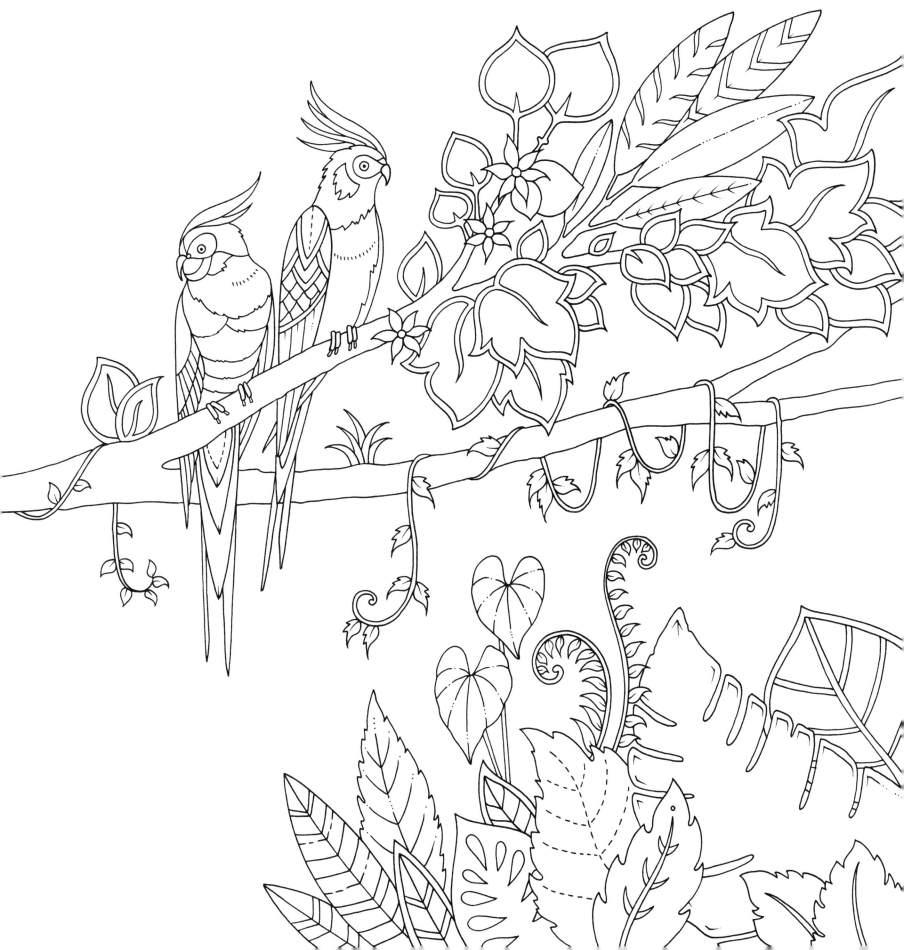

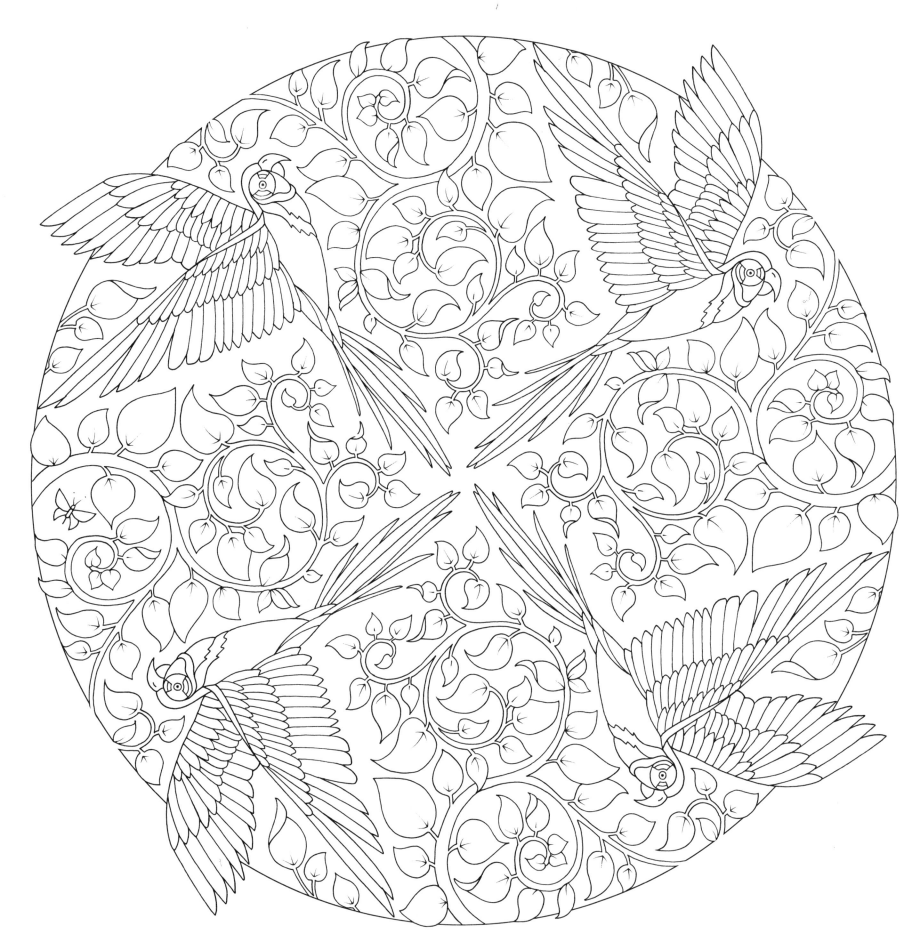

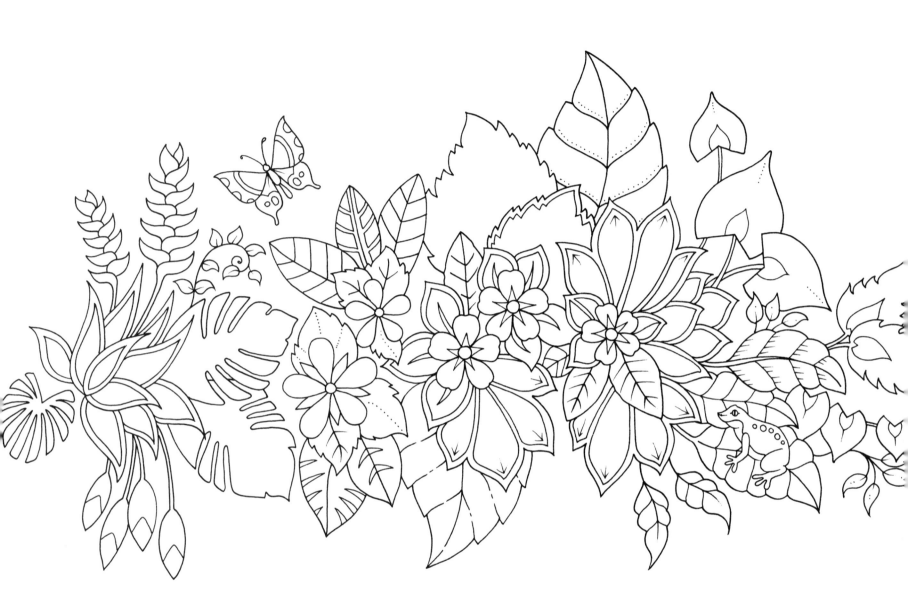

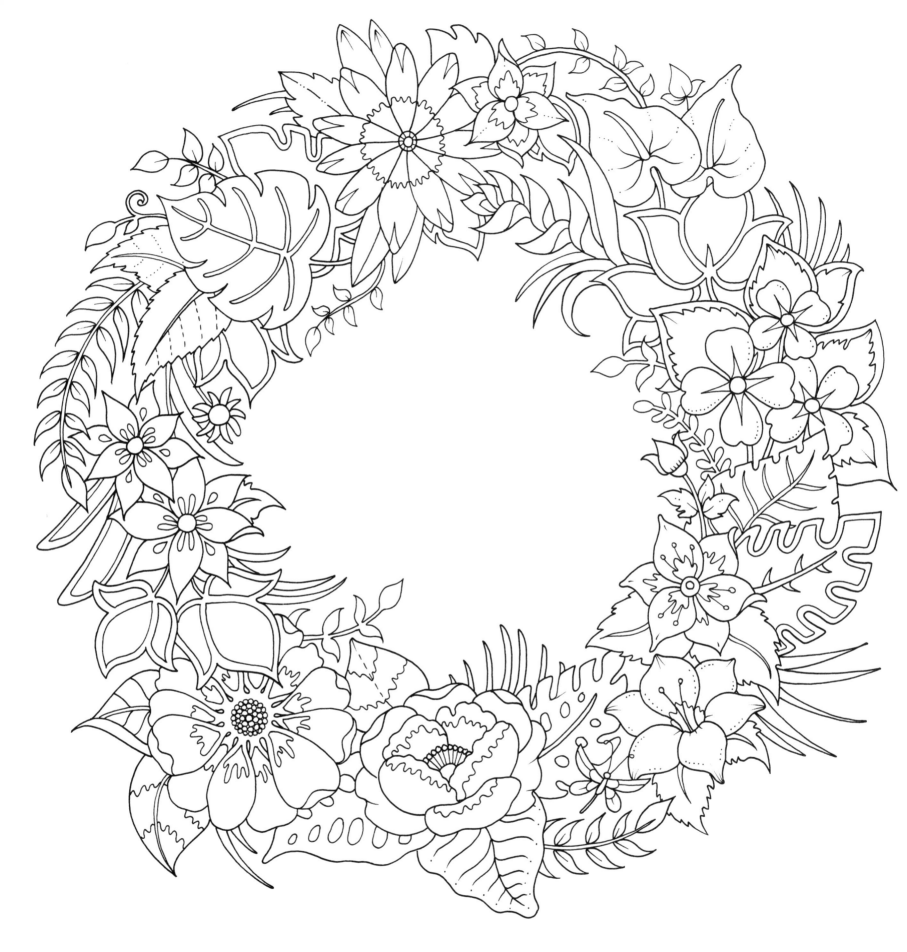

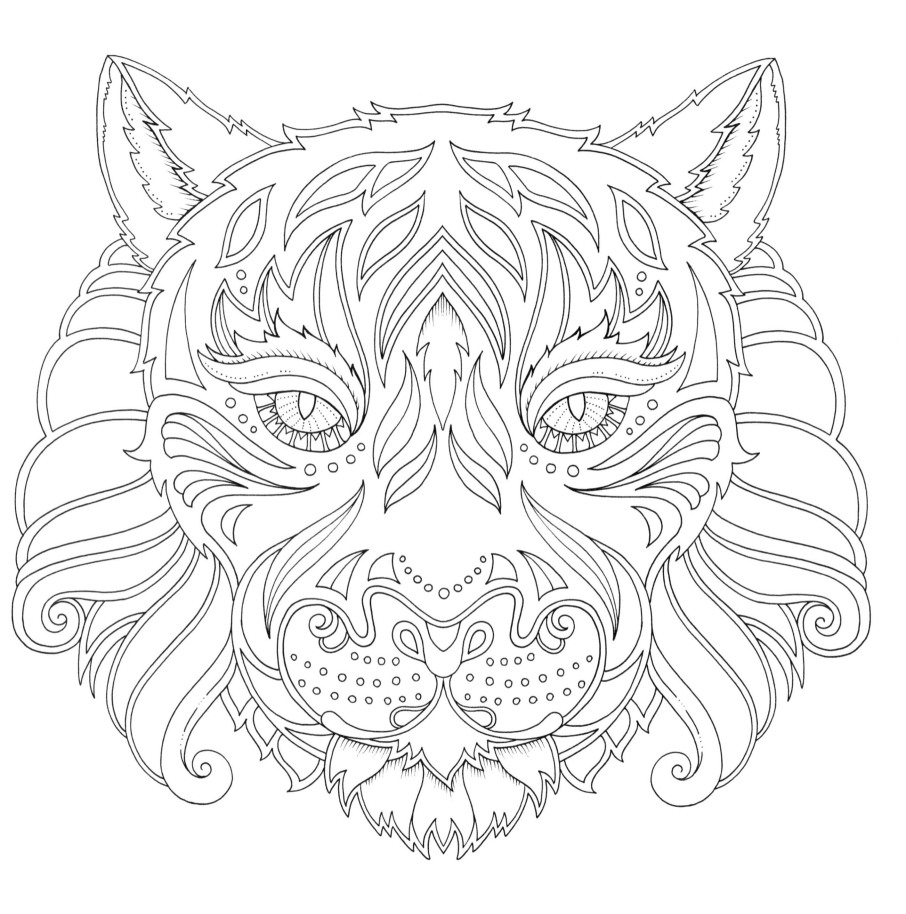

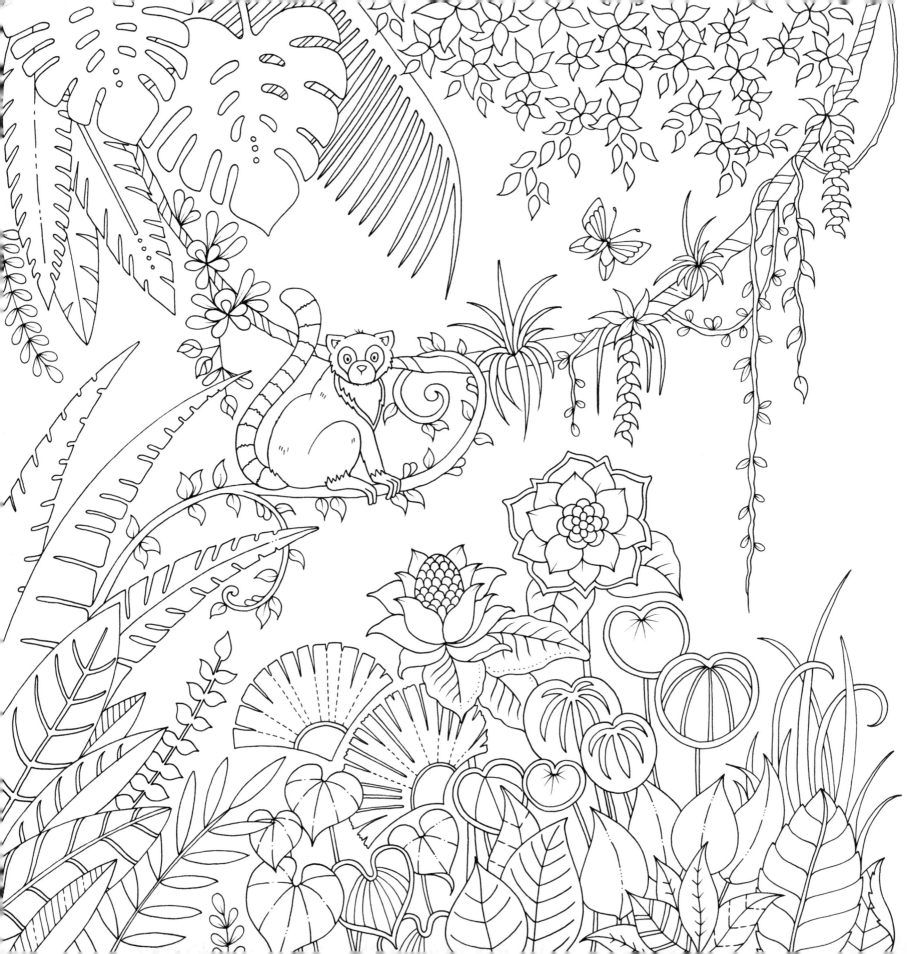

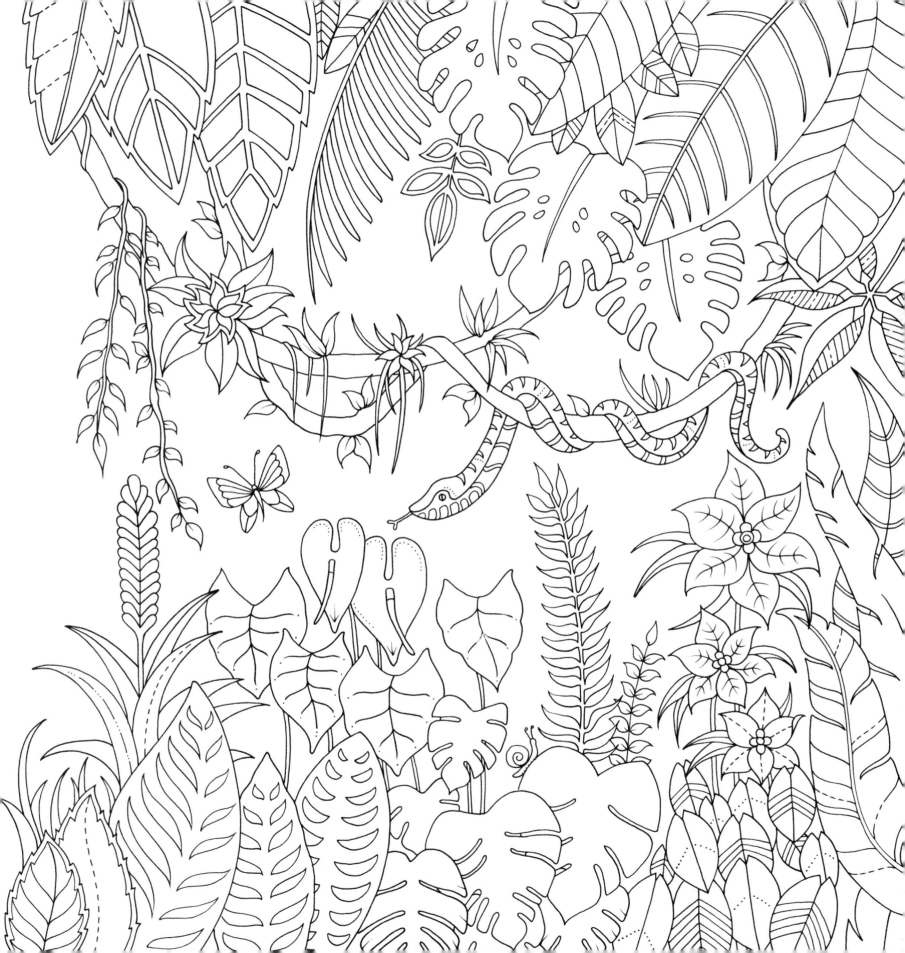

Key to the Magical Jungle . . .

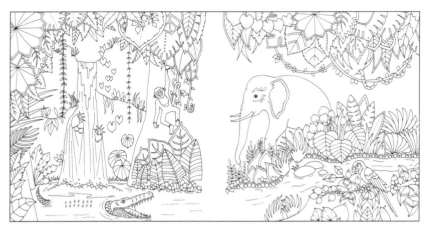

1 monkey, 1 parrot, 1 crocodile, 1 elephant, 1 snake

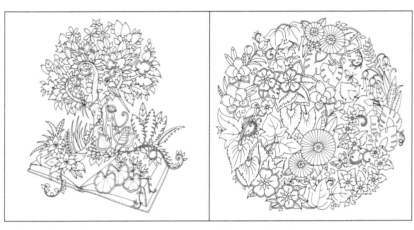

1 monkey, 1 parrot 1 butterfly, 1 parrot,
 1 dragonfly

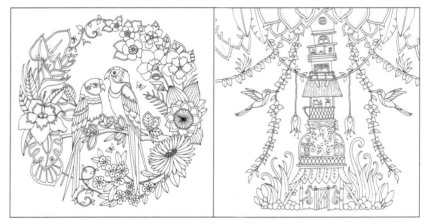

2 butterflies, 2 tropical birds 2 hummingbirds

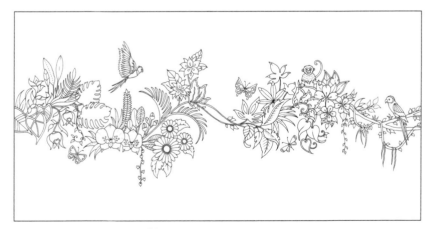

1 monkey, 3 butterflies, 2 parrots

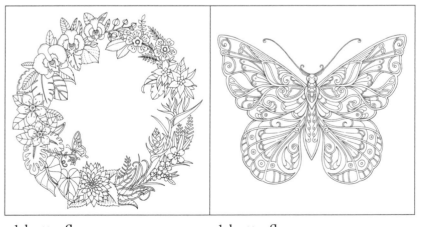

1 butterfly 1 butterfly

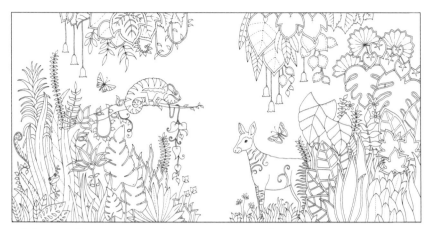

2 butterflies, 1 chameleon, 1 okapi, 1 frog

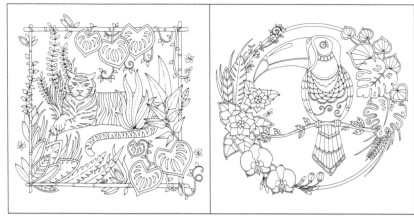

2 butterflies, 1 tiger, 1 snail 1 butterfly, 1 toucan

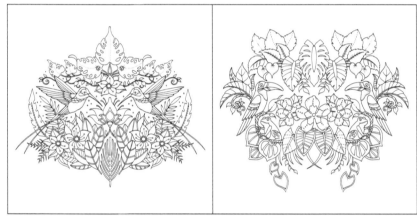

2 hummingbirds, 2 beetles 2 frogs, 2 toucans

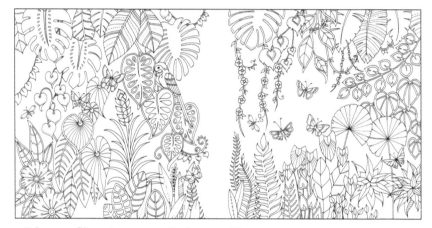

7 butterflies, 1 parrot, 2 dragonflies

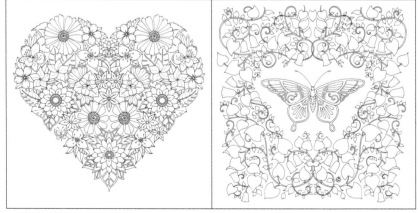

1 butterfly 1 butterfly, 1 beetle

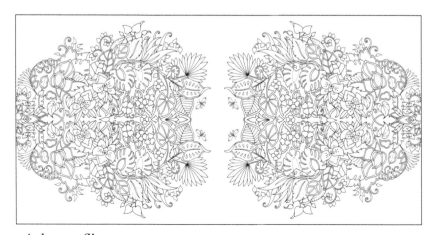

4 dragonflies

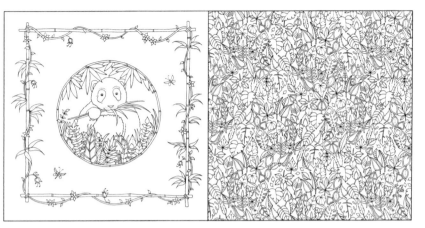

2 dragonflies, 1 panda

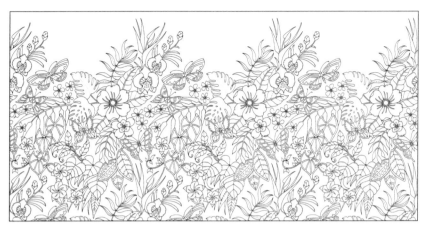

1 lizard

15 butterflies

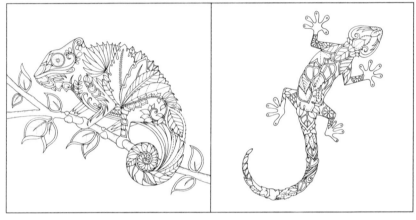

1 chameleon, 1 ant

1 lizard, 1 ant

7 butterflies

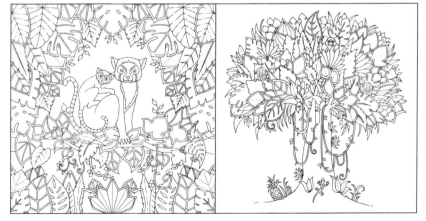

1 snake, 2 lemurs

3 monkeys, 1 lizard

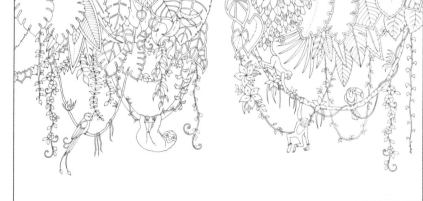

2 monkeys, 1 tropical bird, 1 toucan, 1 sloth

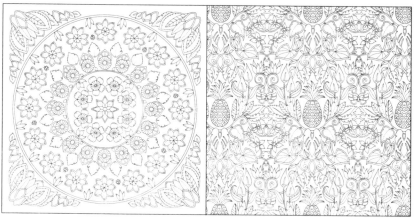

8 beetles

4 butterflies

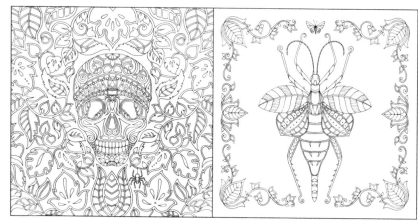

1 spider

1 butterfly, 1 jungle nymph

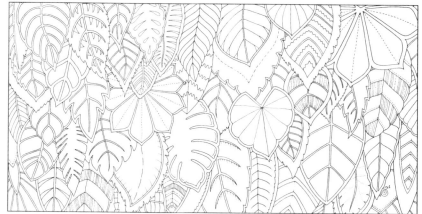

1 snail

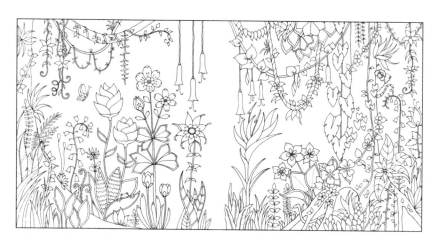

1 monkey, 1 butterfly, 1 snake, 1 frog

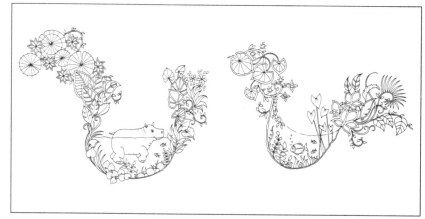

5 fish, 1 hippo

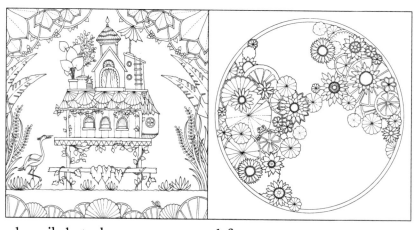

1 snail, 1 stork

1 frog

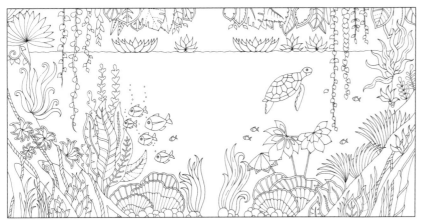

1 snail, 10 fish, 1 turtle

1 frog, 2 fish

3 dragonflies, 1 lizard

1 butterfly, 2 chameleons

10 parrots, 14 elephants

2 lizards

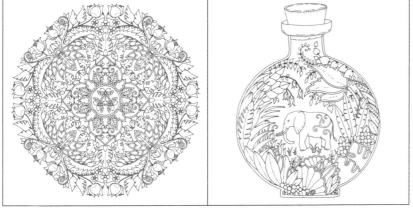

3 butterflies

1 elephant, 1 beetle

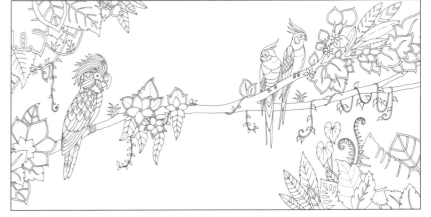

3 tropical birds

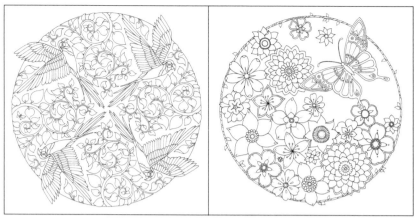

1 butterfly, 4 parrots 1 butterfly, 1 beetle

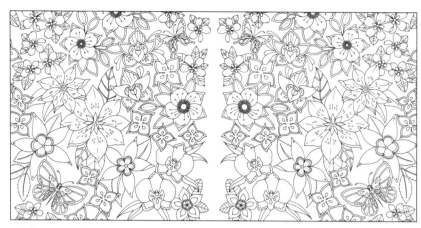

4 butterflies

1 butterfly, 1 frog, 1 toucan, 1 lizard

1 dragonfly 1 tiger

2 butterflies, 1 snake, 1 snail, 1 lemur

Color Palette Test Page

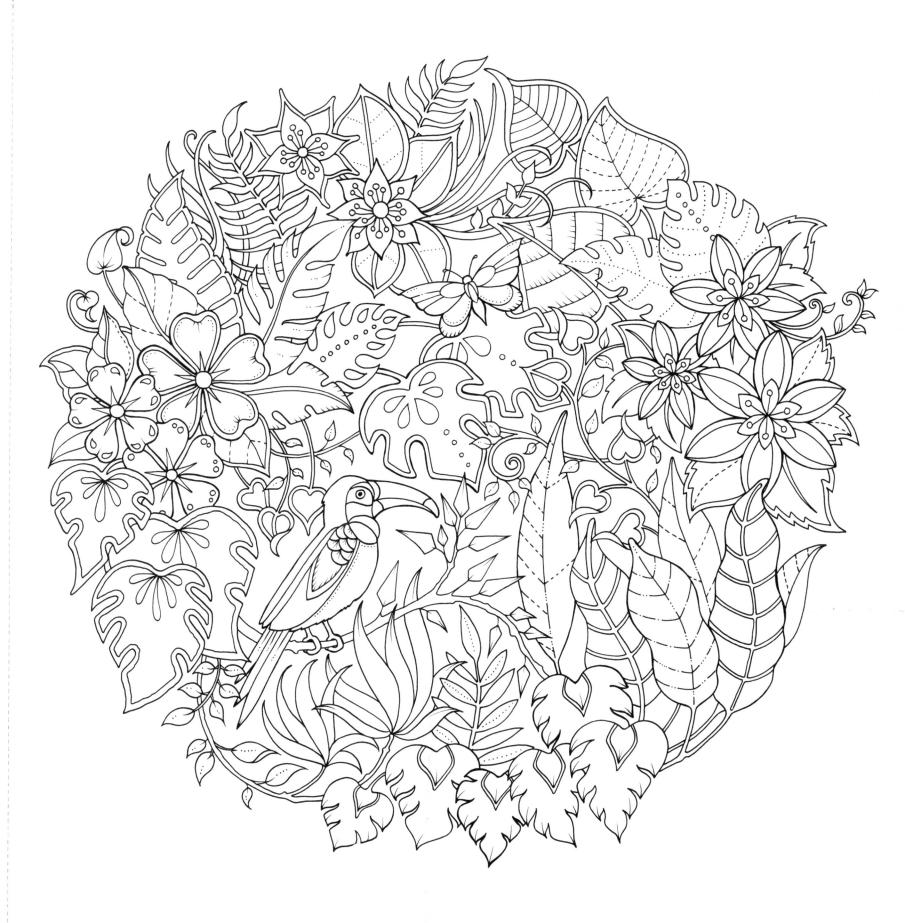

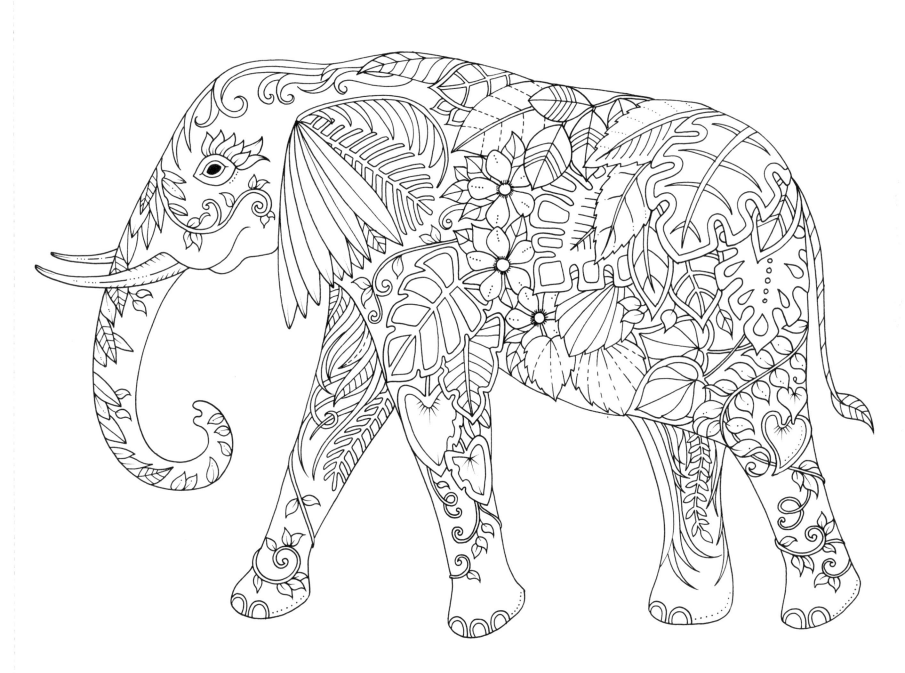

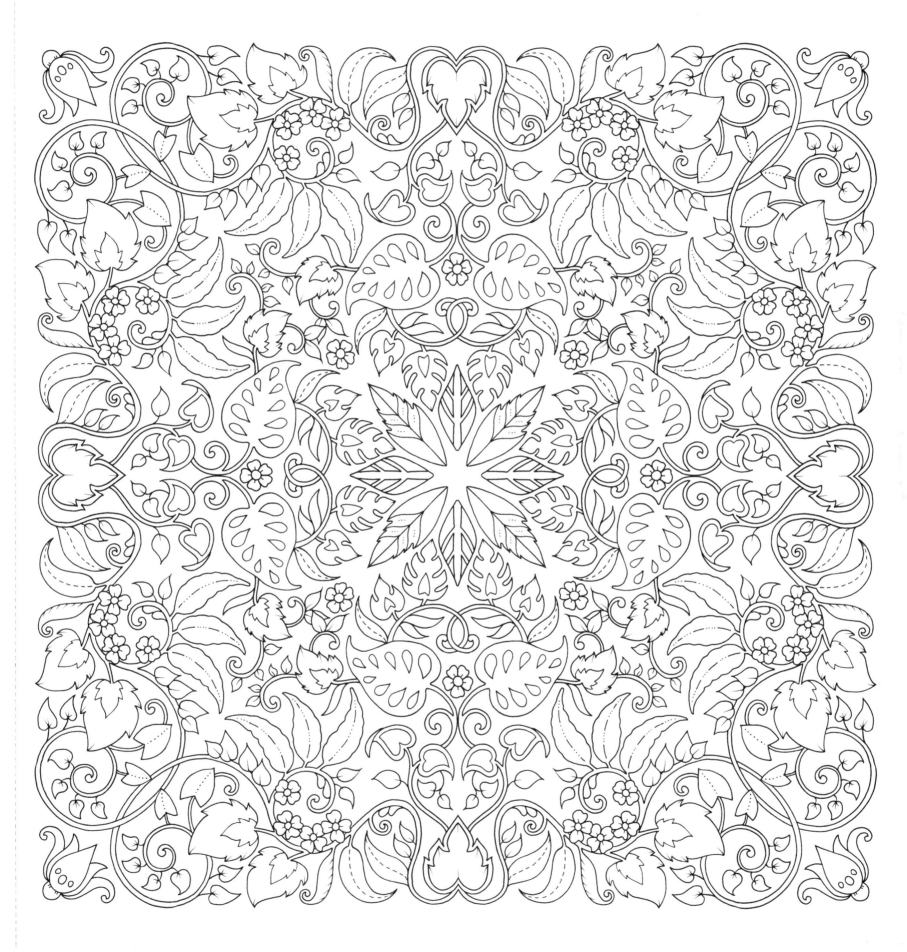

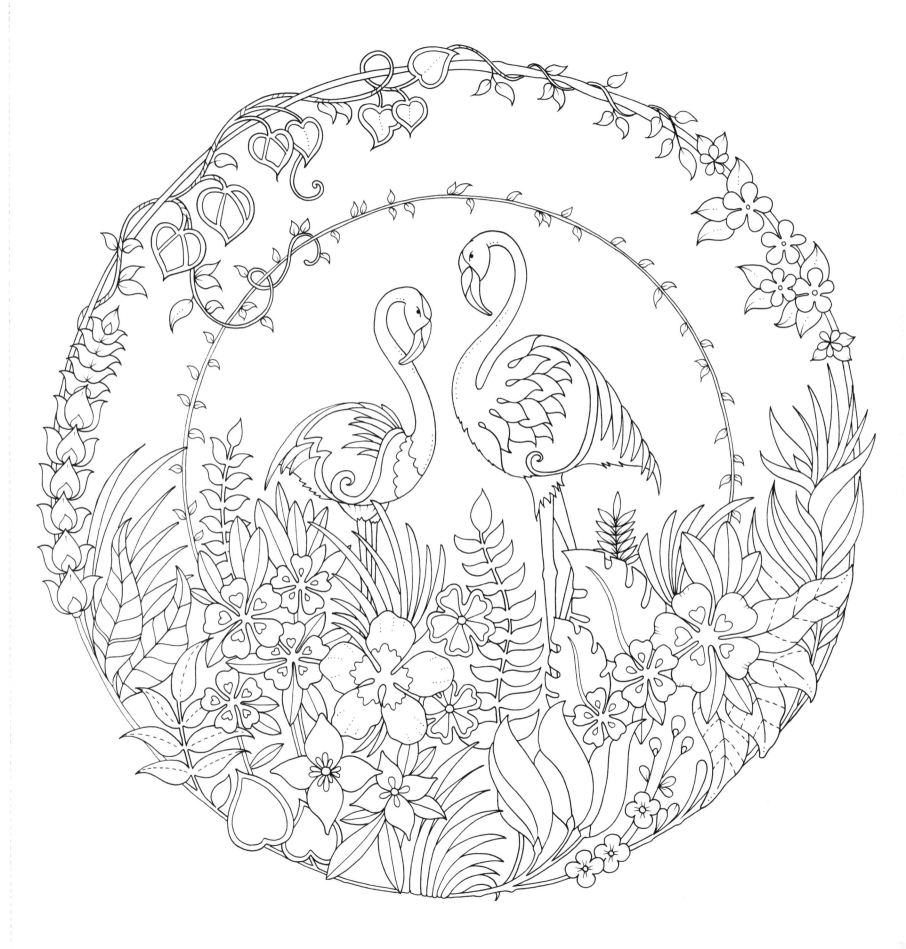